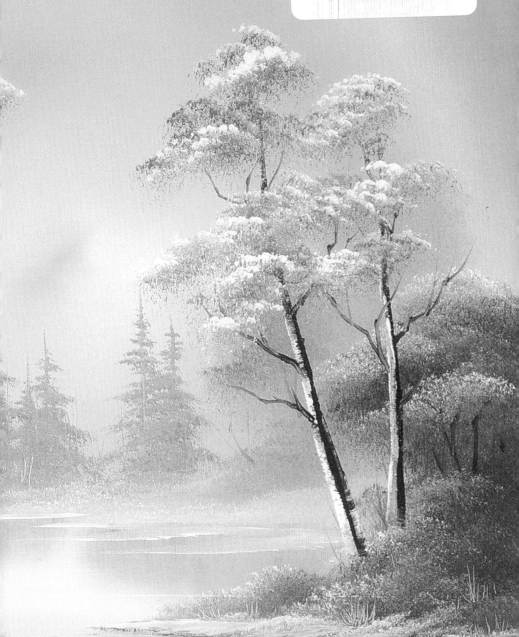

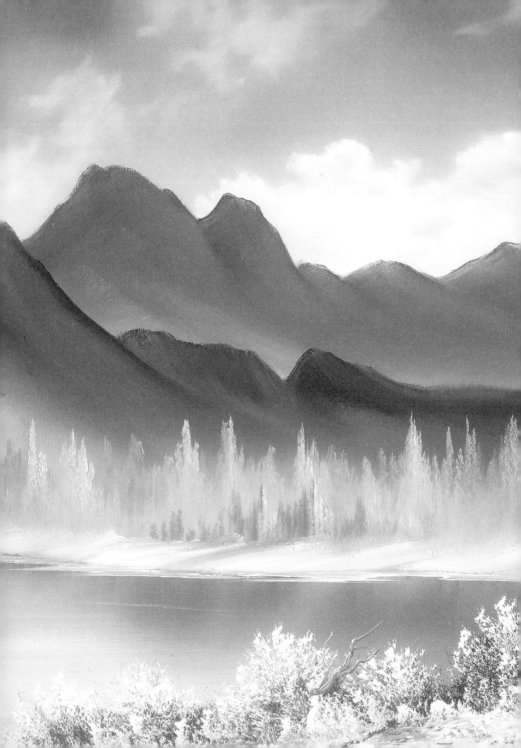

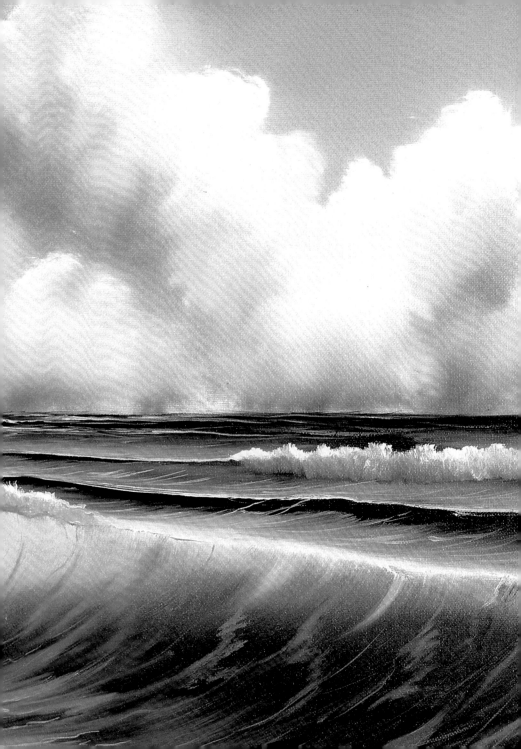

LIFE LESSONS *from*

Be a Peaceful Cloud

Bob Ross and Robb Pearlman

UNIVERSE

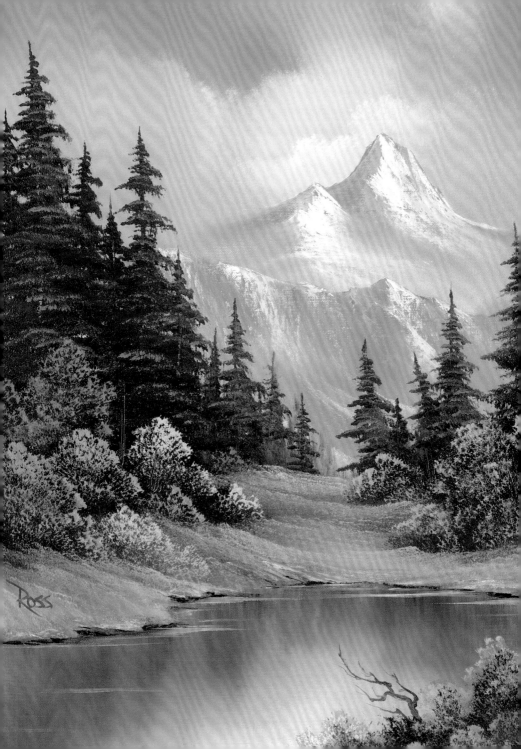

Contents

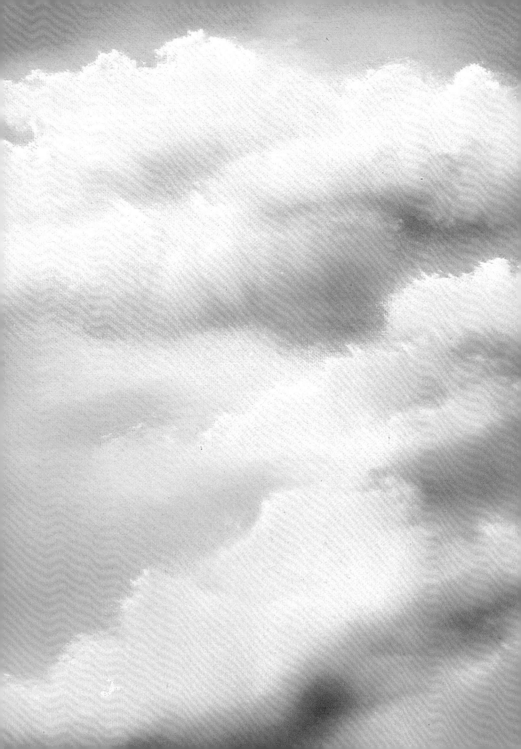

Introduction

"Success with painting leads to success with many things. It carries over into every part of your life."

Modern devices and technologies have revolutionized the way we consume media, but watching television—on an actual television—is an inherently different experience. And as hard as it is to believe (or remember), until relatively recently, watching television on a television was the only way to watch television. And because we invited what and whom we saw on television into our personal and intimate spaces like living rooms and bedrooms, viewers were able to develop a personal and intimate relationship with them.

Countless characters and personalities made incalculable amounts of impact on audiences, but, arguably, one of the most influential of them all was Bob Ross.

Bob Ross was many things during his lifetime: son, husband, father, United States Air Force master sergeant, businessman, painter, television personality, and teacher. And though he was successful and respected in each of these roles, his impact as a teacher cannot be overestimated. Because Bob didn't just teach people how to paint, prepare a canvas, or clean brushes.

Whether he knew it or not (and I think he knew it), Bob spent each of his *Joy of Painting* episodes and personal appearances teaching us how to live.

There's a proverb that says if you give a man a fish you'll feed him for a day; teach a man to fish and you'll feed him for a lifetime. Bob taught us how to tap into the skills and imaginations that we already have to paint landscapes and riverscapes teeming with enough wisdom to feed our souls for a lifetime.

Bob's devotion to teaching was so natural that he was able to effortlessly weave lessons about painting with lessons about life. Meditative, elegiac, and heartfelt, these lessons have taught generations about imagination, friendship, kindness, mistakes, and finding happiness. And they are as well received—and necessary—years after his death as they were during each of his twenty-two-minute televised episodes. Originally broadcast into our homes as appointment television, and now available wherever there's a Wi-Fi connection, Bob still speaks to us all in the most intimate and personal ways.

I think the reason each and every person feels as if Bob is speaking to us personally is, very simply, because he was. Bob was a teacher, and we were all his students. He may not have known our names, but he knew our potential and our hearts. As Bob would say, "Isn't that great?"

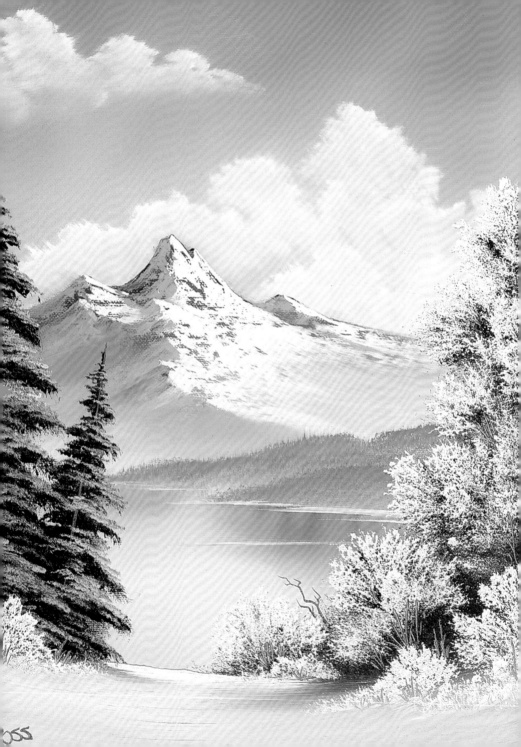

Blank Canvas

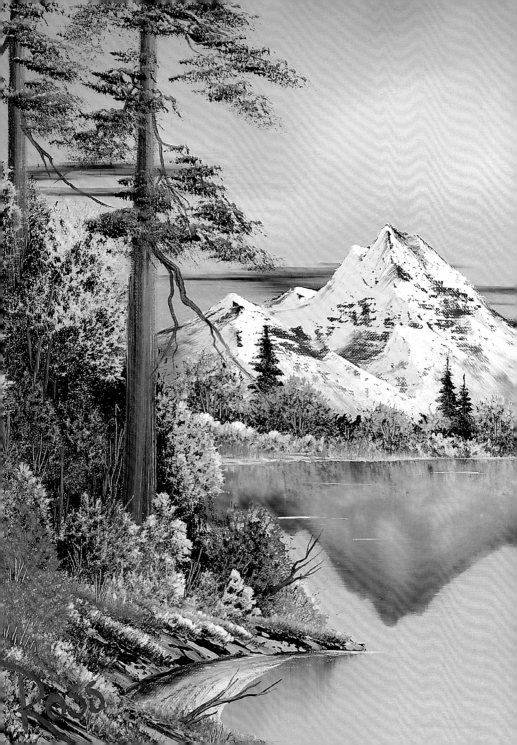

"Today I think we'll do a happy little painting, bright and shiny and pretty, just something that'll make you feel good."

You are an artist.

Whether or not you believe it, you are an artist.

Bob Ross said that you are.

And he's right.

Statistically speaking, your paintings will probably never be exhibited in a gallery or museum. But who cares? Your work can be and is seen by countless people every day. You are an artist because you use your imagination, natural talent, and learned skills to paint the picture that is your life. You are an artist because you wake every morning, see the blank canvas that is your day, and create something that's never been seen before. You are an artist because just by thinking and creating and doing, you inspire and influence others to think and create and do.

Your day is a blank canvas to paint upon. Empty, it can be filled with as much fear as promise. You can spend hours debating which brush to use, where to apply the first paint stroke, how to calibrate the correct amount of pressure to make sure the (hopefully right choice of) color works in the way you want it to, what other people will think about it, and how you'll know when it's finished.

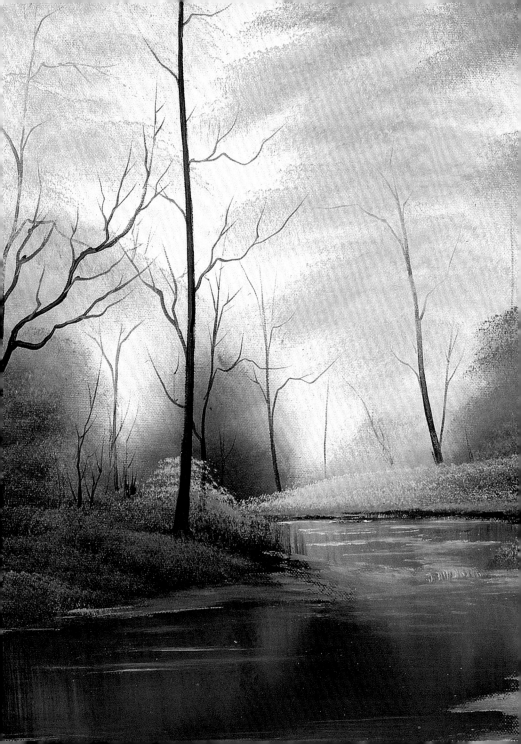

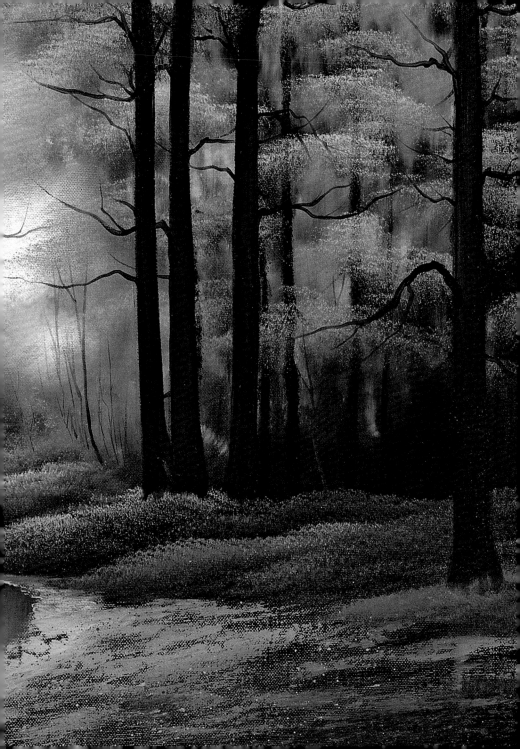

"Let the canvas work for you. Allow the colors and the paint—everything—to work together to make it easy."

To Bob, blank canvases weren't really blank. Stretched across a wooden frame and made of natural cotton, he saw each canvas being as unique as the painting it would soon hold. Every canvas bore its own life's experiences as plainly as any person's physical scars or wrinkles. Before Bob painted a tree or a cloud, he prepped a new canvas with a layer of Liquid White basecoat to serve as a neutral and fresh start to each painting. This didn't remove the natural discolorations or textural features that appear on every canvas, but provided him with an idea of where the imperfections lay, how they could be worked with—or enhanced—and gave him a sense of the base he was working with. Each canvas, even those with supposed imperfections, was perfect in its own way.

Of course, the blank canvas that is your day is never going to be completely blank. It will be affected by work, family obligations, health issues, the weather. And though you may not be able to control many—or any—of these factors, you can control how you react to them. By seeing your day as a blank canvas, and starting out by mentally coating it in a layer of Liquid White, you'll give yourself the opportunity and time to assess what you have to work with, and how you can best work with it. Rather than covering up or obscuring the underlying issues of the day, you'll actually be reorienting your perspective and giving yourself a fresh start to see them in a new, neutral, way.

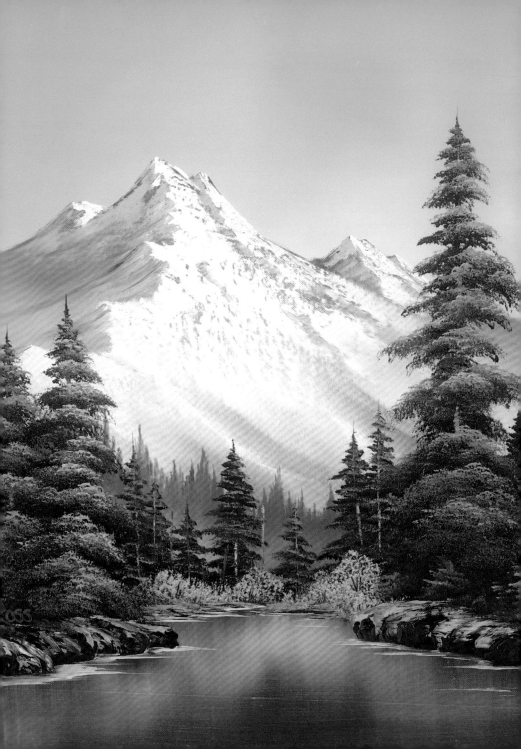

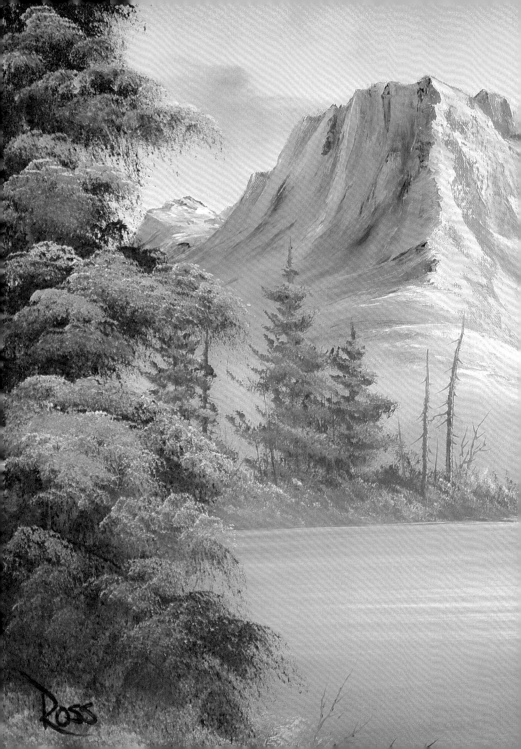

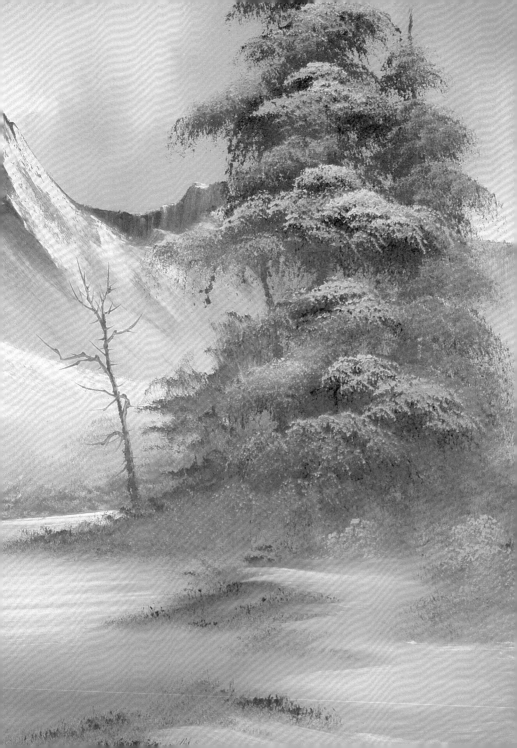

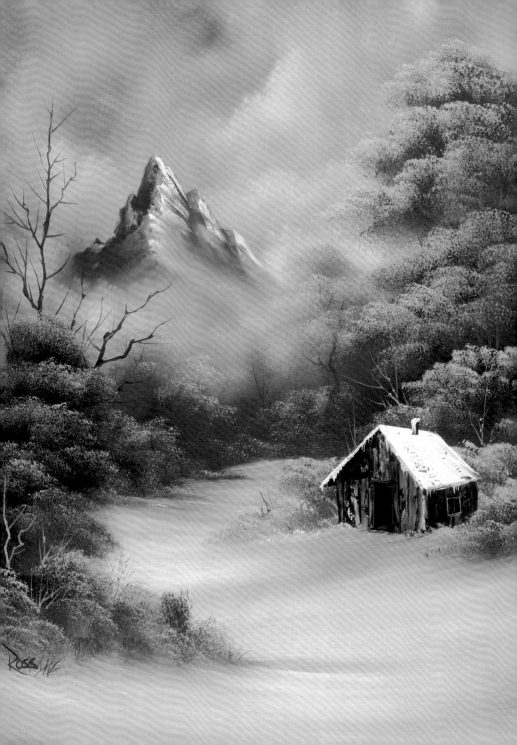

"Things that just happen are sometimes more beautiful than things you really sit and plan."

Bob rarely started a painting without an idea of the general direction he was heading in. (He knew, of course, that there would be happy little accidents along the way.) Whether it was a painting focusing on a small, snow-covered cabin, or one featuring a magnificent mountain range bathed in midsummer sunlight, Bob was aware, to some degree, of what the painting would look like in the end.

Before you start to paint your day, come up with a broad plan. What would you like to see or feel? What do you have to work with? What colors would you like to use? What techniques are you interested in trying? If you start your day combining your understanding of the canvas with your artistic goals, you'll not only be better prepared to make your first strokes, but feel more at ease throughout the process. By having some idea of what you want to see by the end of the day, and how you're going to achieve it—with the full understanding that happy little accidents and diversions are going to happen along the way—you're putting yourself in an important position: you will look at the painting of your day with a sense of satisfaction of your accomplishments (or at least with the understanding that you tried your best).

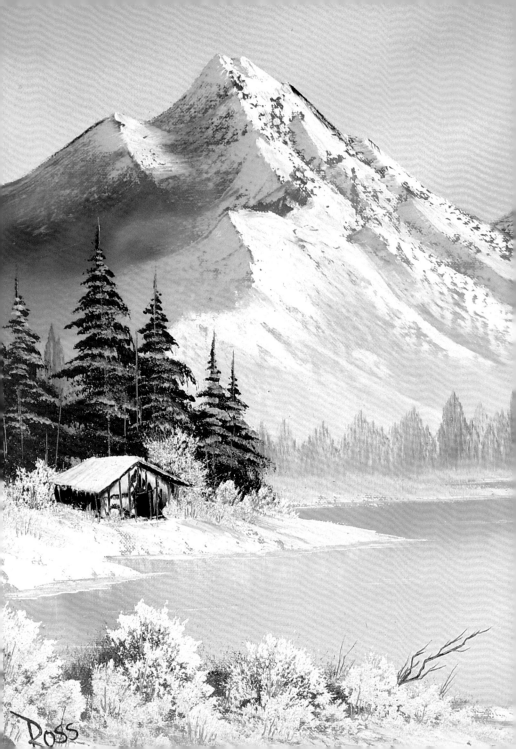

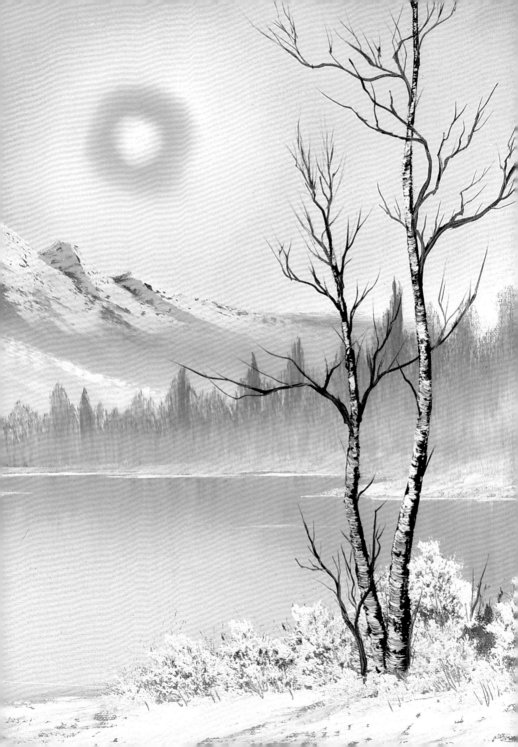

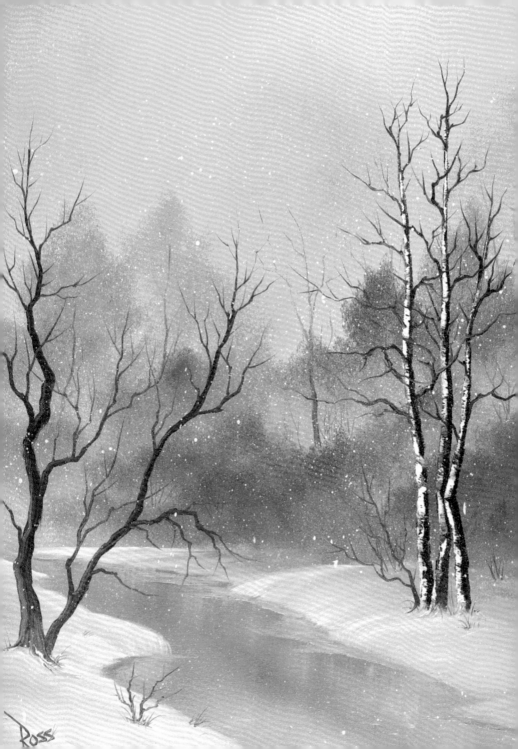

"The more you paint, the easier it becomes. It's like anything else—when you first started tying your shoe, it probably didn't work the first time. You had to practice it a few times. And now you can do it without even looking. And it's the same way with painting. Pretty soon you can do it, and it just happens."

Days, like blank canvases, are in ready supply. There's always a new day to work with. Even if you feel like the painting you just created wasn't an accurate representation of your skills, or didn't turn out the way you'd expected, there is nothing stopping you from picking up your paints and starting again.

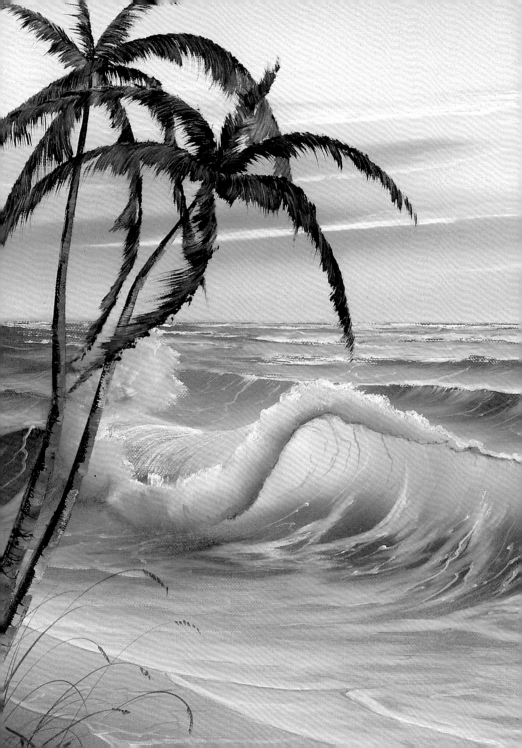

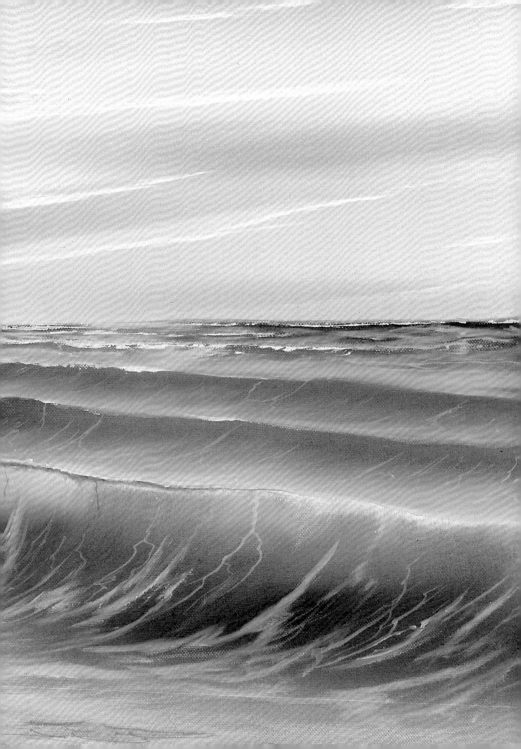

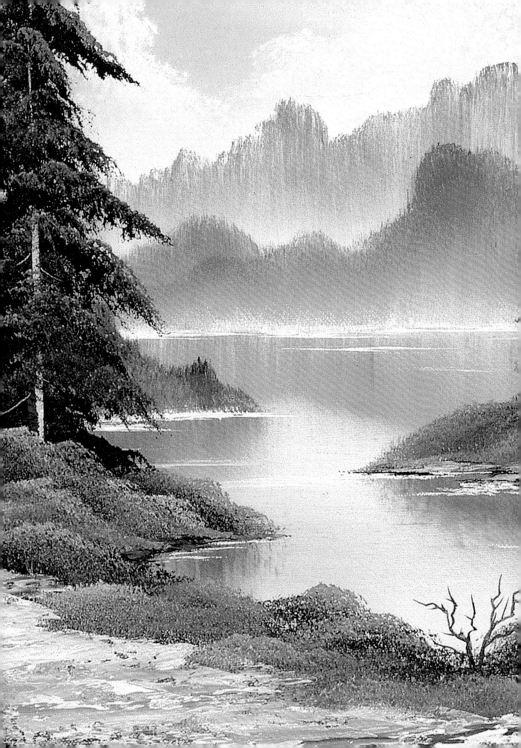

Streams

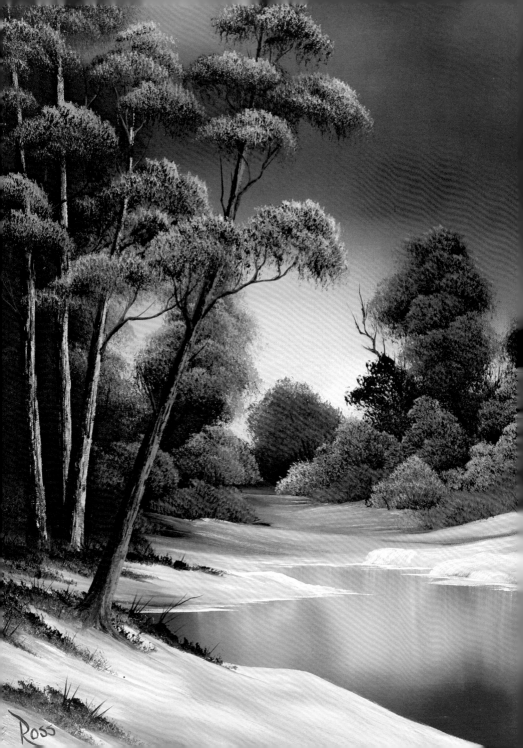

"Here's a stream—it comes right out by this tree. Let it wind around and take its time."

Why rush? Bob completed a beautifully detailed landscape during each episode of *The Joy of Painting*, but he never gave viewers the impression that he was ever in a hurry to finish it within the twenty-two-minute allotted airtime. Bob never *seemed* rushed because he wasn't. He knew he'd get to the end when he got there, and the painting would be done when it was done. The winding, meandering streams featured in Bob's paintings are ideal representations of Bob's beliefs in patience and taking one's time.

In Bob's paintings, the streams are never straight. This is because in nature, water finds its way down from the snowcapped mountaintops to lakes and oceans. This is not a quick process. It took thousands, if not millions of years for streams and rivers to carve their paths through the earth. Drop by drop, streams and rivers were formed around rocks, through silt, under mountains until, eventually, they reached the ocean, only to evaporate into the atmosphere, form happy little clouds, and start the process over again. They work their way around boulders and impediments knowing, in literal and metaphorical due course, that they will reach the ocean when they're meant to.

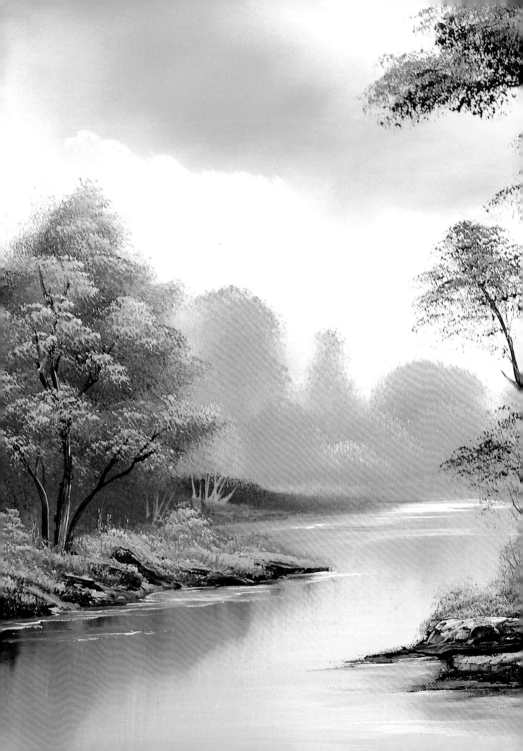

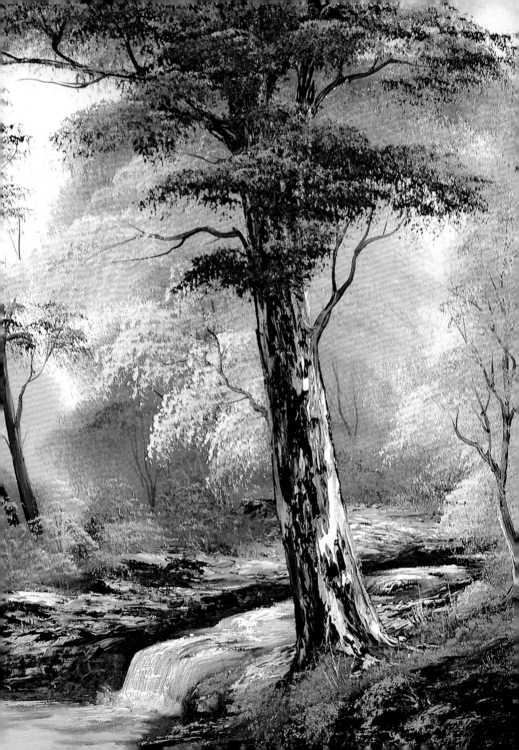

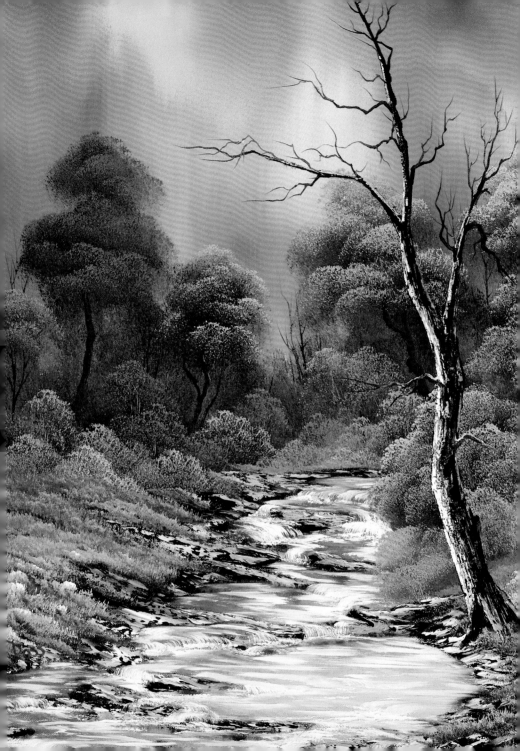

"The more you paint, the more you're able to visualize...you really can learn to be creative as you paint. It's like anything else—it just takes a little practice."

Bob believed that everyone had the ability to be a painter. However, he also recognized that it takes time to learn proper painting techniques. (If he didn't, there would have been only one episode of *The Joy of Painting*!) Bob also believed that everyone needs to keep practicing (and practicing some more) in order to truly master a skill. Of course, some of us pick things up more quickly than others, but we can all get there in our own time.

This same idea can be applied to pretty much anything you want to accomplish. You're never going to be an expert at something the very first time you try it. In fact, if you start a project with that attitude, you will certainly be disappointed and much more likely to give up. But if you stick with it, practice, and, perhaps most of all, give yourself the leeway to accept some happy little accidents a few (or more) times, you'll slowly but surely build your achievements, grow your skillset, and reach your end goal.

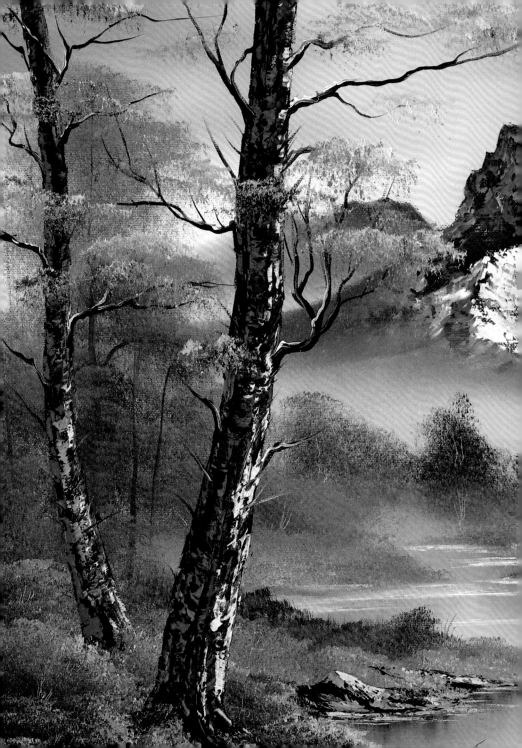

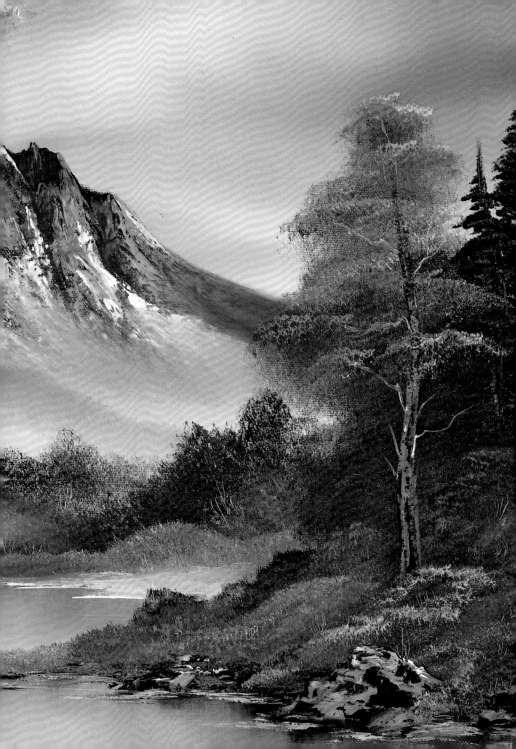

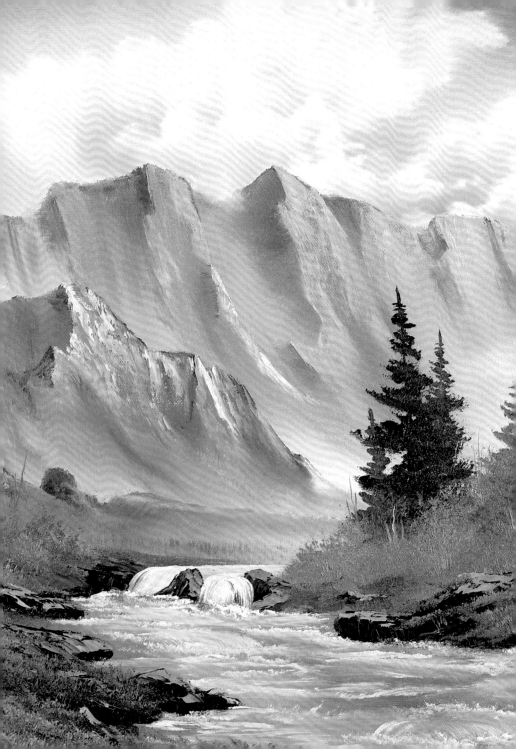

"Don't overmix your paint. Just relax, be calm, be peaceful, but let it go."

Bob was patient. Bob was born in Florida in 1942, and the first episode of *The Joy of Painting* didn't air until 1983. That made him forty-one years old at that first broadcast, well past the traditional age for breakout television personalities. Bob needed to get to a stage in his personal—and professional—life where he was ready to get on camera. Public television didn't think he'd missed his one shot at success, and his business partners, Annette and Walter Kowalski, and Bob's wife Jane, certainly didn't think he was too past his prime to teach untold numbers of students how to paint in his in-person classes. He did all of that and more, when the time was right for him to do it.

We're constantly trying to meet deadlines or benchmarks based on expectations (whether our own or other peoples'). How many single people say, "I need to be married by the time I'm thirty"? How many artists decide not to take a painting class because their dexterity isn't what it used to be twenty years ago? (In fact, Bob used to say that seniors were good painters because their sometimes unsteady hands created such beautiful tree branches.) Many people believe there's a timeline that they need to follow. As Bob would say, that's "baloney."

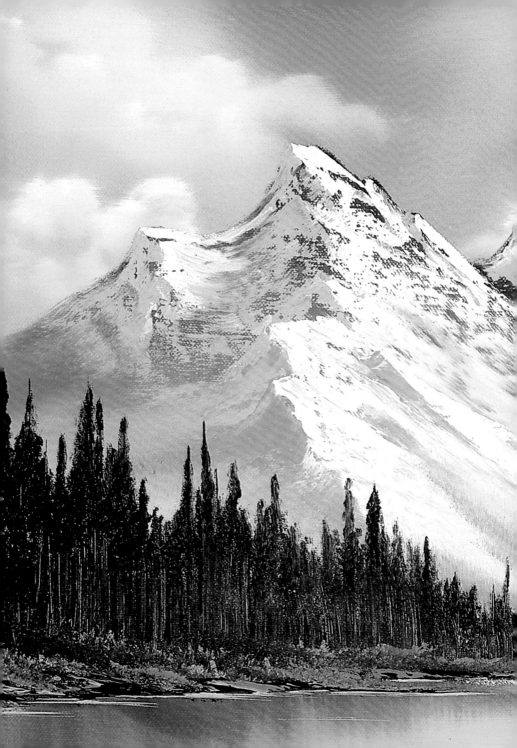

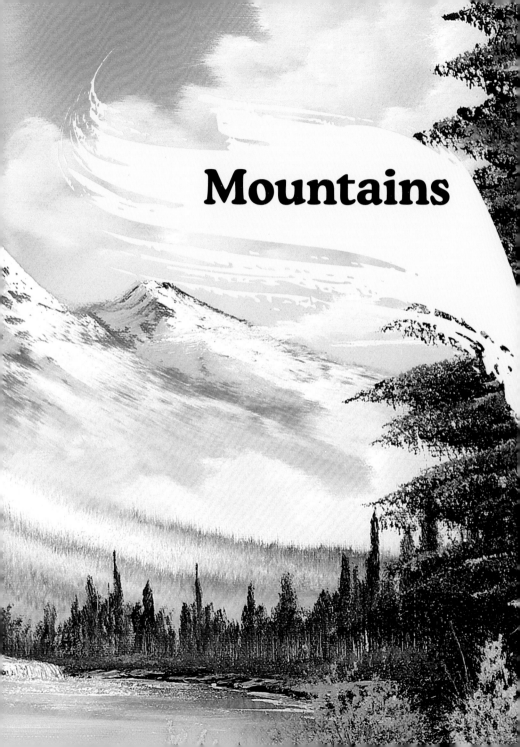

Mountains

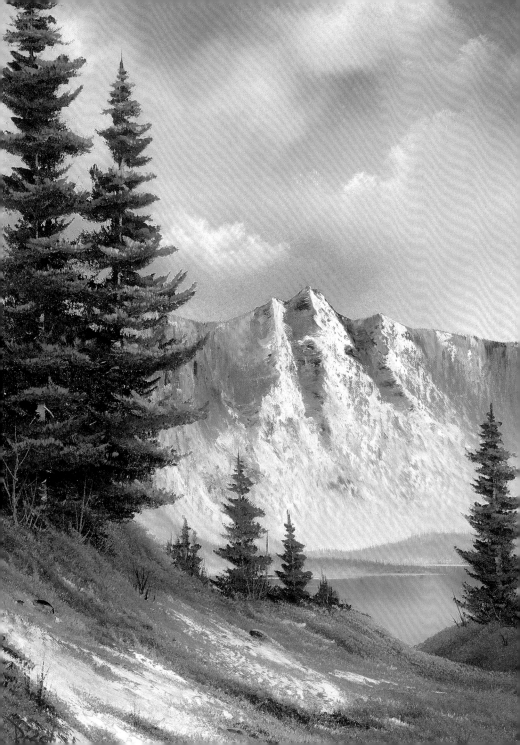

"The top of the mountain is always more distinct than the bottom of the mountain."

Whether large or small, challenges are very much like the mountains Bob painted. As hard as it is to believe, even a television personality as iconic as Bob was still just human. As a real person, he faced many of the same challenges everyone does (though perhaps he had to spend more time getting paint out of his clothes than most of us). In the majority of Bob's paintings, mountains are in the background. Yes, they provide a lovely and perspective-affirming juxtaposition to the underbrush and rocks in the foreground, but they also represent the obstacles that either have been overcome or will need to be overcome by whoever is walking in those woods.

So many of us see our problems as mountainously insurmountable obstacles. Titanic in size, rocky, and topped with freezing snow, they're simply too big to deal with. But when you get closer to them, you notice things you may not have seen before. Slopes are easier to ascend. Trails appear. Bushes and trees and snow provide sustenance. And sometimes, when you least expect it, you'll find other people to help you to the top, where you can see a whole new view, filled with opportunity.

As mountainous as your problem may seem from a distance, ask for help; you'll see that your problem is not something that needs to stop you in your tracks. It's a hurdle to get over. And, when it's in the distance behind you, it will make for a lesson learned and to be shared.

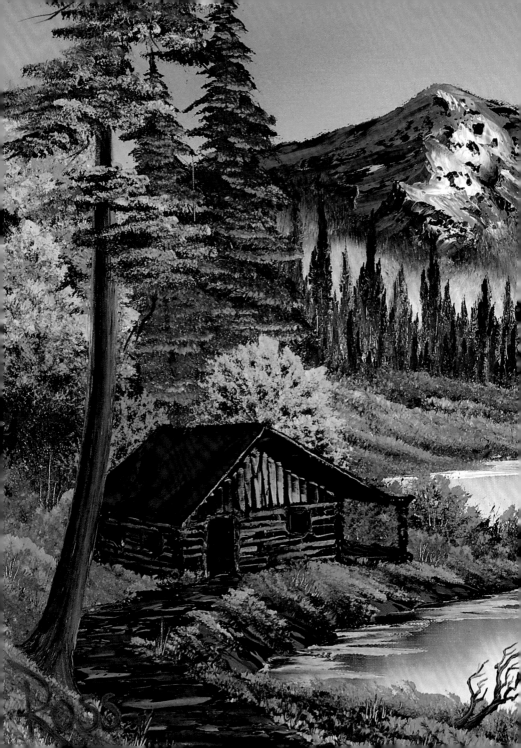

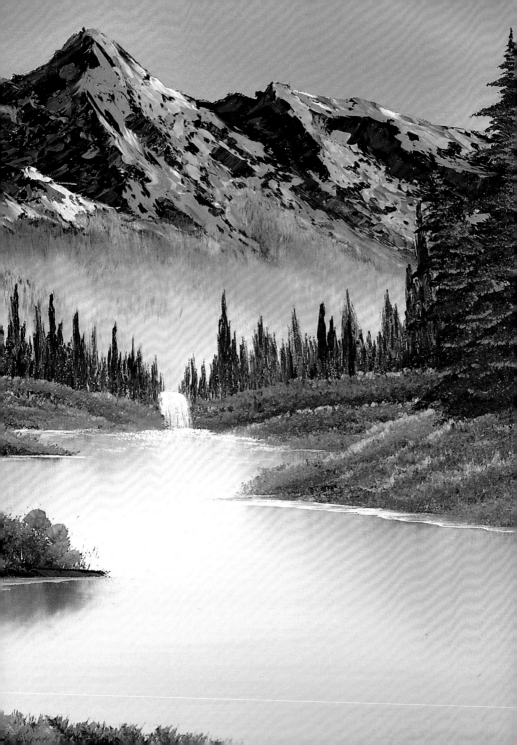

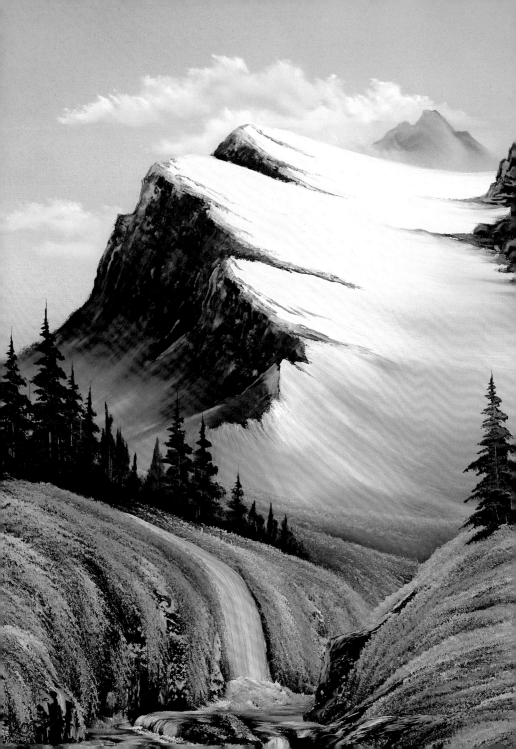

"You can move mountains, rivers, trees—you determine what your world is like. It's your mountain, so you put it where you want it."

Bob's life, like everyone else's, was filled with challenges. As a teenager, working on a project with his carpenter father, Bob severed one of his fingers. Rather than letting this incident derail, if not define, his entire life, Bob made the decision that carpentry probably just wasn't for him. He joined the United States Air Force at eighteen, where he spent the next twenty years. After being discharged, Bob taught art classes, but he and they were far from instant hits. In fact, Bob's classes were so poorly attended that he tried to save as much money as he could—including reducing the number of haircuts he needed by getting a perm. Yes, Bob's signature curly locks began as a way to save money. Instead of giving up, Bob figured out a way to work through his problem and, in the end, turned what could have been a career-ending issue into one of his career's most recognizable and iconic features.

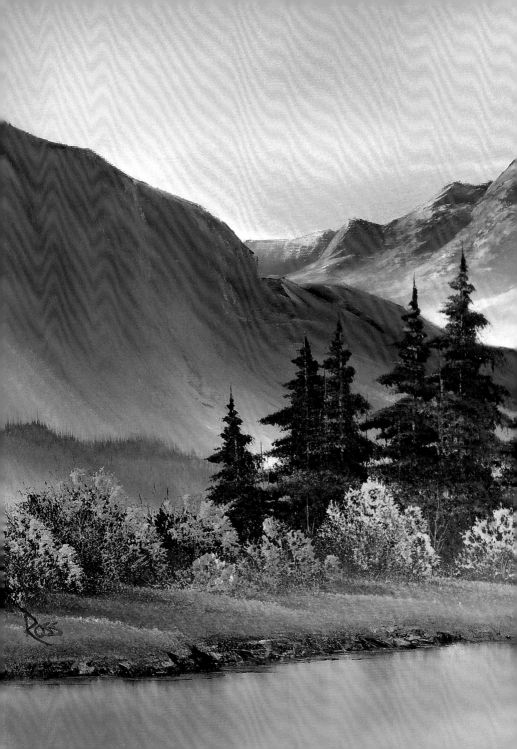

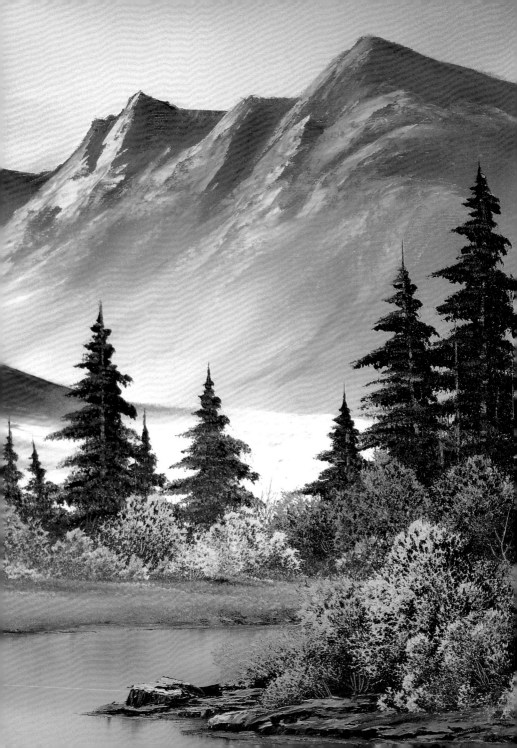

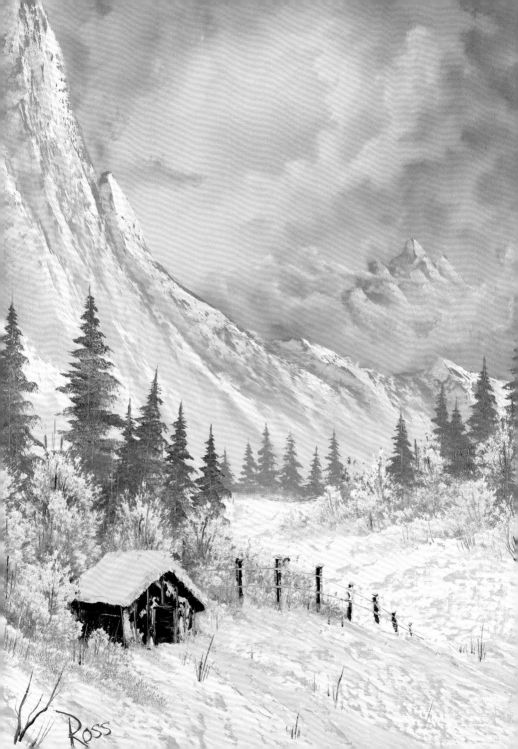

"I don't try to understand everything in nature. I just look at it and enjoy it."

The mountains in Bob's paintings are neither ominous nor insurmountable. Often shown in direct sunlight, these are not obstacles that are to be hidden from view or never discussed. Instead, they are evidence of struggles or barriers that, with some time and effort, can be overcome or traversed. You can go over, around—or yes, even through—that mountain range and find ourself in a quiet and refreshing place, where a warm cabin waits to shelter you.

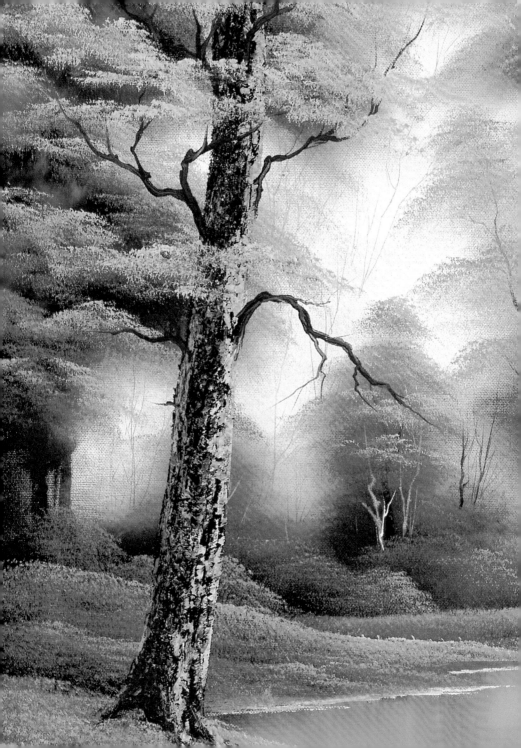

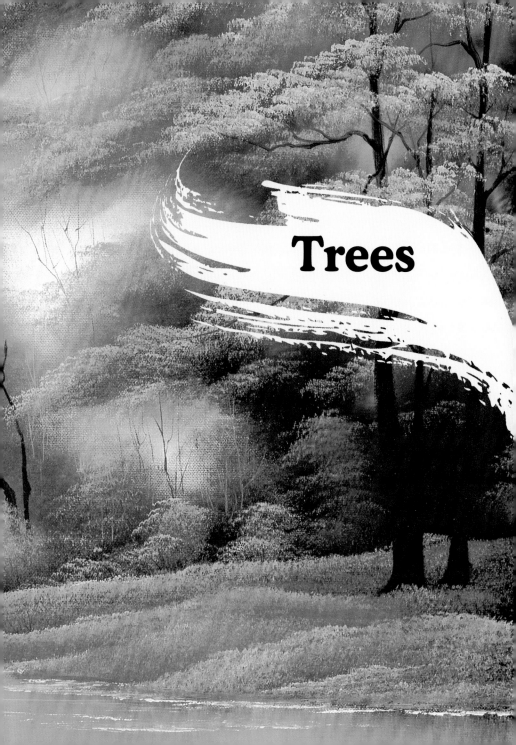

Trees

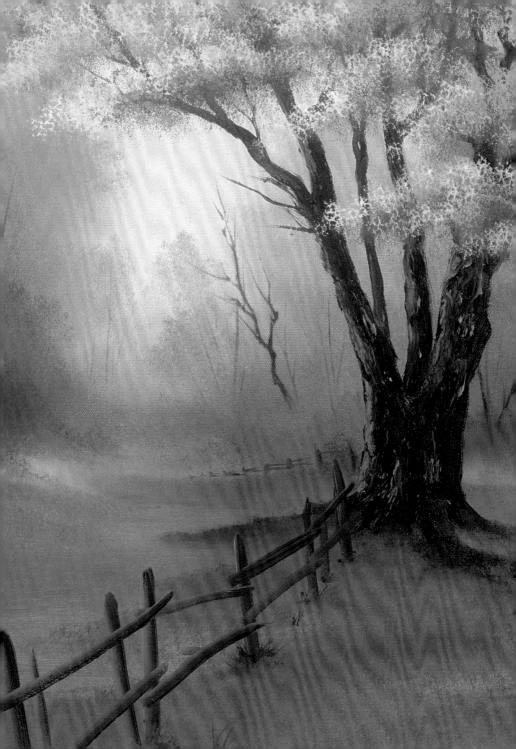

"Trees are like people. They have personalities—each one's different, each one's an individual. If your tree doesn't look just like mine, that means it's probably better."

Bob's paintings featured trees of all shapes and sizes. Some were thin and some thick, some straight and some gnarled, some dead or dying and some bursting with color. But each of the trees, whether alone or joined with friends, was supported by roots and, in turn, provided shade and shelter to the squirrels and birds who eat, play, and rest in and around them. These trees, no two alike, represent the importance of being supported... and being supportive.

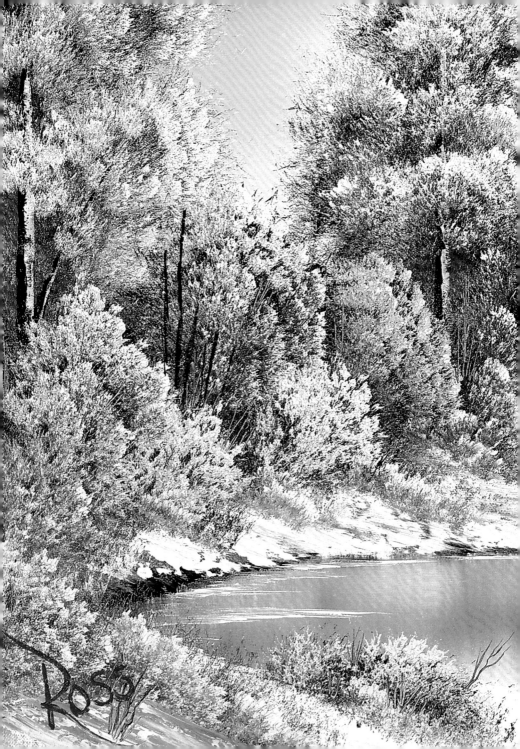

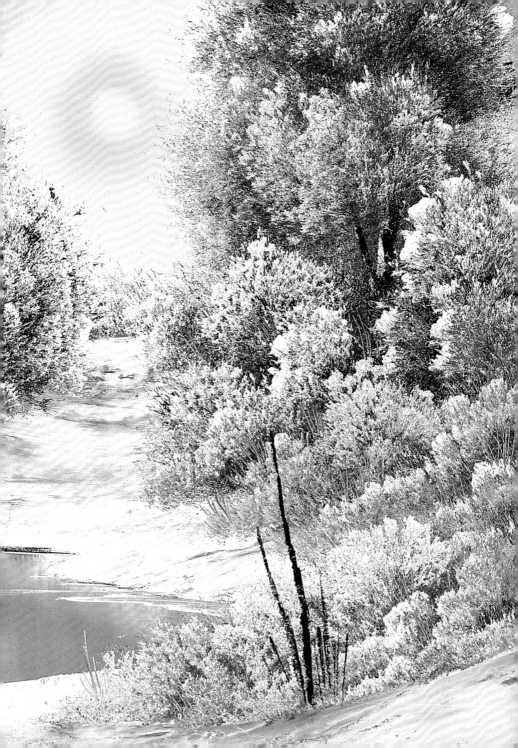

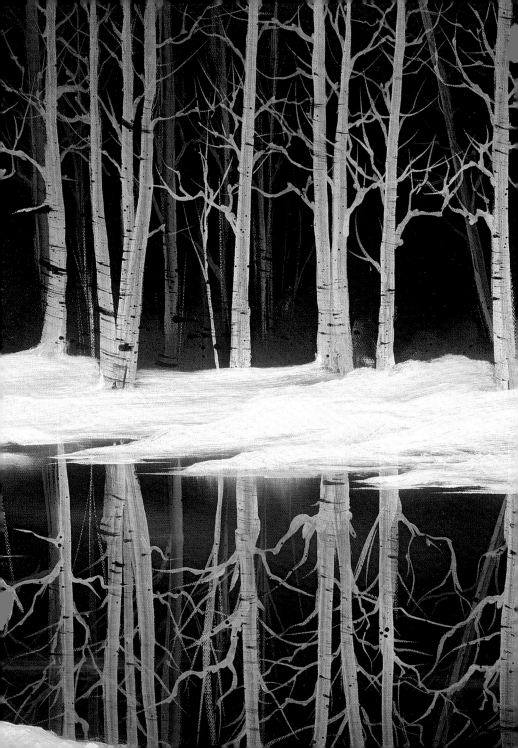

"Friends are the most valuable things in the world, and even a little tree needs a friend."

Because viewers usually saw only Bob painting on camera, many might have believed he was a one-man operation. But nothing could be further from the truth. From the beginning, Bob was fortunate enough to have parents who encouraged his artistic ability and love of nature. He was then surrounded and supported in his military duties and artistic efforts by his fellow corpsmen in the U. S. Air Force and then by family and friends who helped him launch his career.

It takes an enormous number of people to put together a television show. Their names may not be as familiar as Bob's, but Annette and Walt Kowalski ran the business side of Bob Ross Inc., ensuring that tours were arranged, supplies were procured, and that Bob himself, and now his legacy, remain at the forefront of art instruction and pop-culture relevance. Bob was deeply rooted in the community that supported his growth; in turn, he was able not only to grow and flourish but also provide entertainment, education, and a respite from the world to all who seek to sit beneath his verdant, wide-reaching branches.

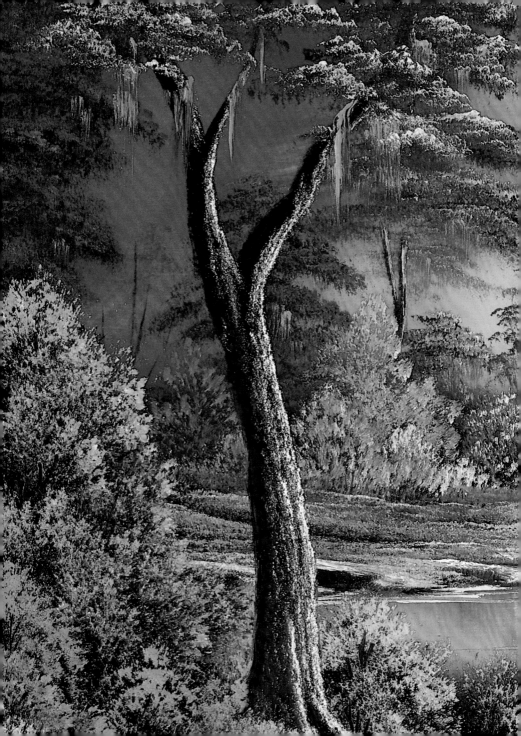

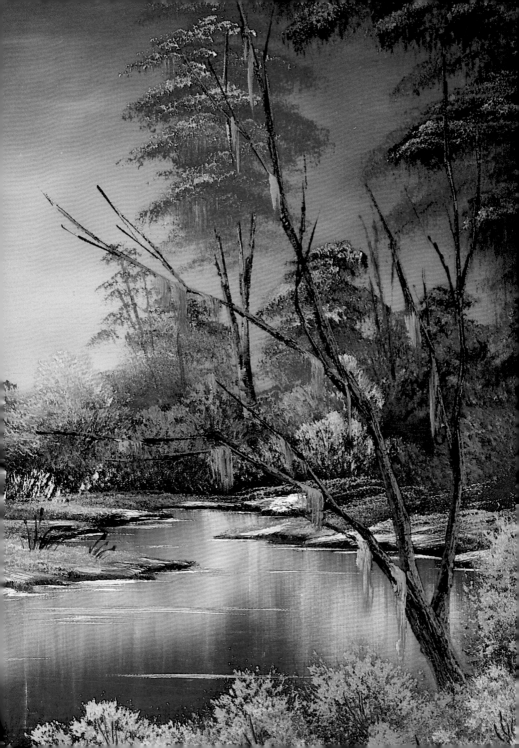

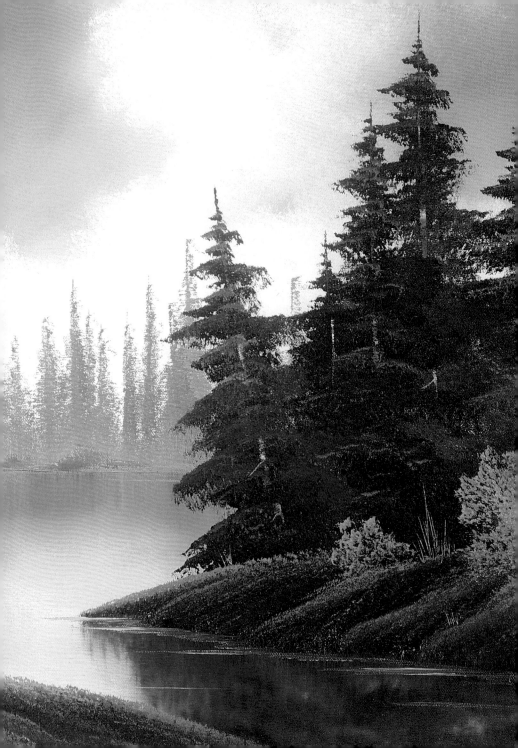

"You know what will happen if there are two trees. Pretty soon there will be three and then four, and then you're going to have a whole forest."

Many of us pride ourselves on our self-sufficiency, but nobody can do *everything* on their own. Everyone, at some point in their life, needs the support of other people. Whether it's trying to get over that mountain—or just figuring out which brush to use to paint a mountain—we all need a firm and nourishing support system to grow to be our best selves. Hopefully you come from a family with the emotional and financial ability to support you, or, if not, have been able to find yourself in a family of choice, a friend circle, or community who encourages you to live your best life. These are the people—the ones who know and love you for who you are—who provide emotional and spiritual nourishment.

As Bob proved by teaching millions of us how to paint, we each have a responsibility to pay it forward by helping, nurturing, and encouraging others as best we can. Whether it's a child, a neighbor, a student, or just someone walking down the street, share your gifts, fortune, and talents with them to the best of your ability—it benefits you, as much as them. If you're a good cook, try volunteering at a community food bank; if you're an artist, teach a children's finger-painting class at your local library! Or, if you have a few extra dollars, how about supporting your local public television station! Think of how grateful you were, and are, for the help, structure, and encouragement you're provided by friends, family, and even strangers. Remember that small kindnesses and modest efforts can mean as much as grand gestures.

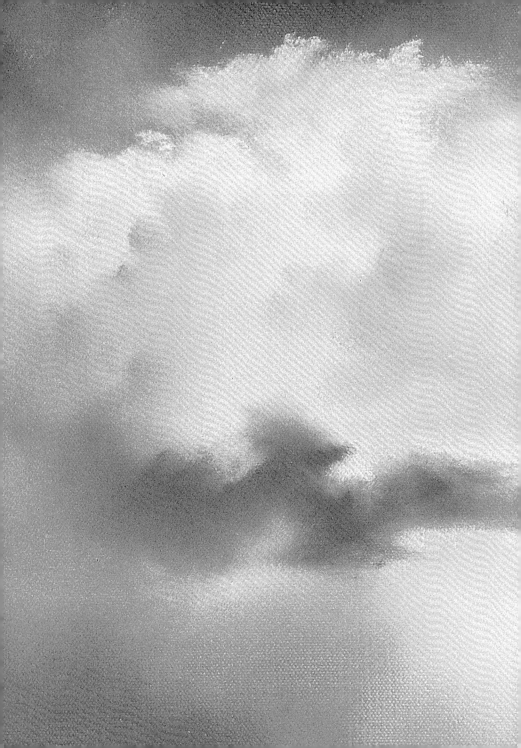

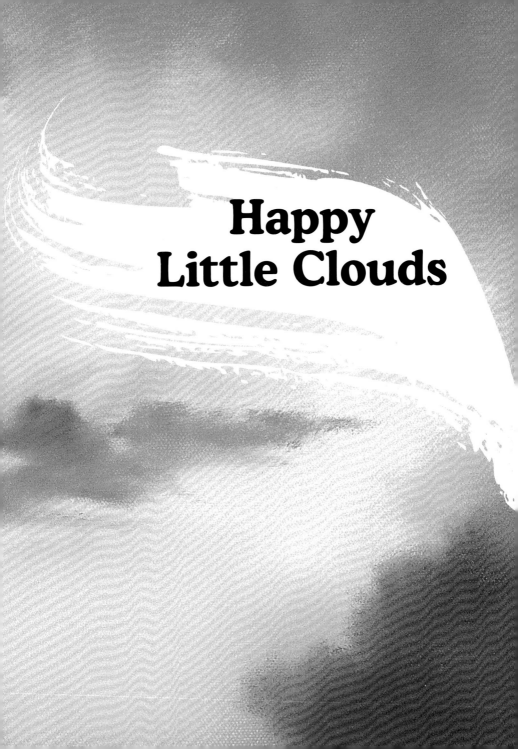

Happy
Little Clouds

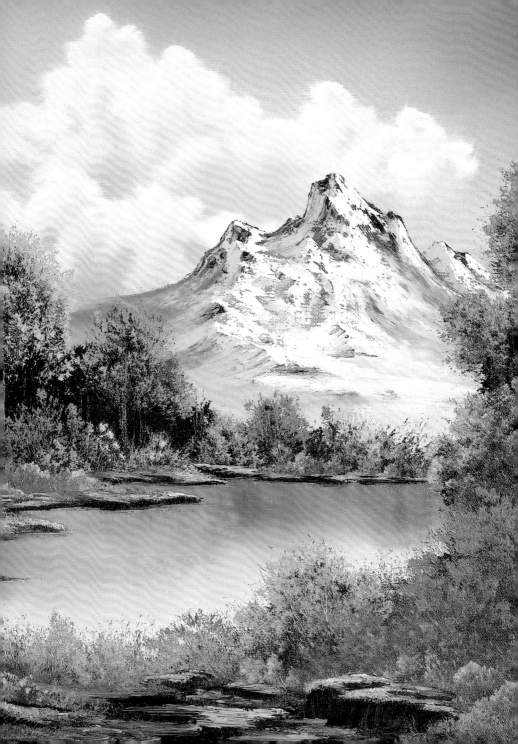

"Let's make some nice little clouds that just float around and have fun all day."

Bob knew that to be his best, he needed to enjoy some downtime and self-care. After all, he wasn't painting all the time. An ardent lover of nature, he could often be found walking along trails with his camera or fishing. He also loved to spend time with family and friends and even go antiquing. Bob's happy little clouds remind us that sometimes you just need to sit back, relax, and float.

When was the last time you did something that was just for you? Something completely unrelated to your job or your familial responsibilities? If you have to think about it for more than a few seconds, then it's been too long. In order for you to be there for others—your children, partners, parents, coworkers— first you need to be there for yourself. That could mean a day at the spa, reading a book, or even relaxing on the couch while painting along to an episode of *The Joy of Painting*.

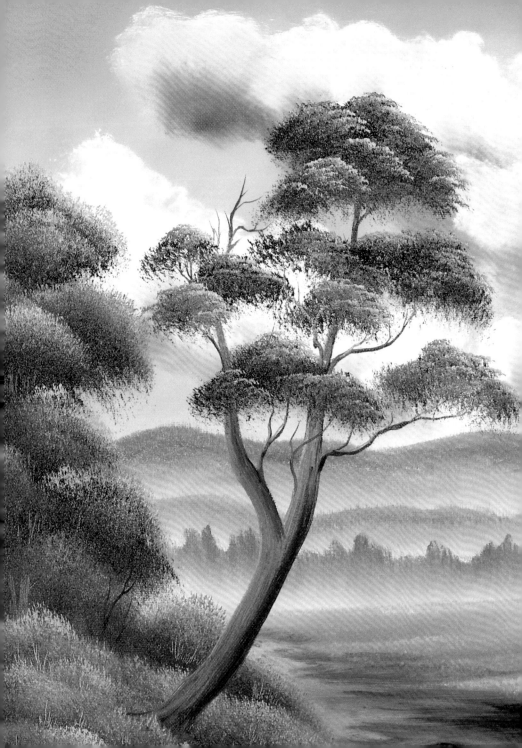

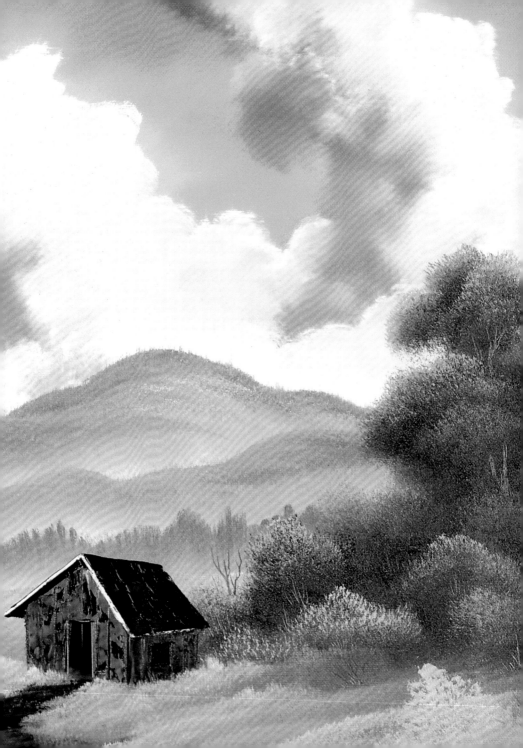

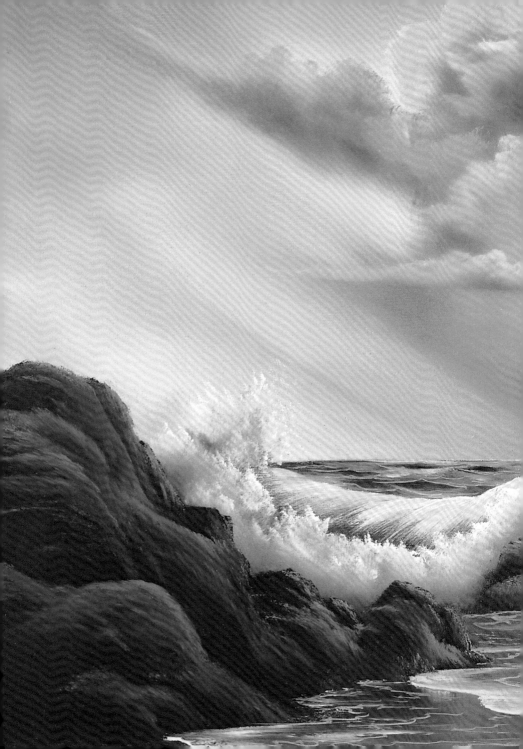

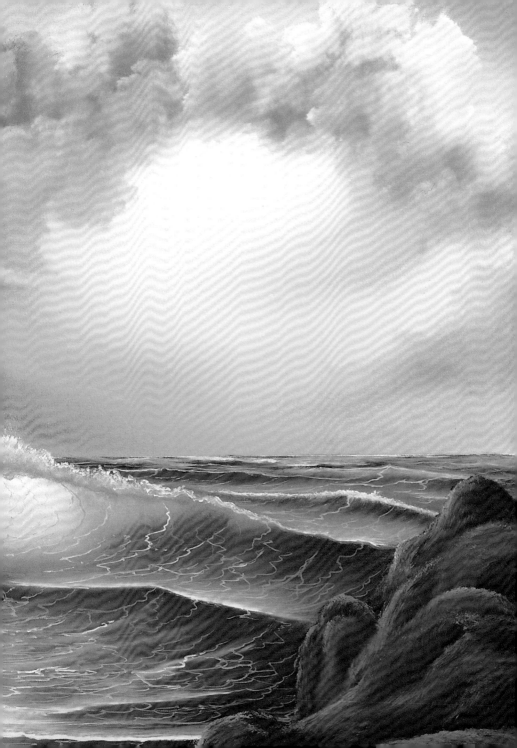

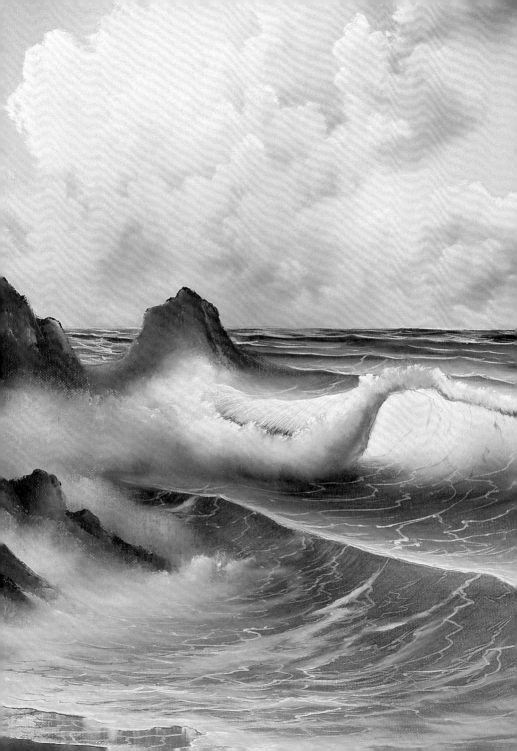

"In your world, you just look around and decide where you want a little cloud to live, and that's where you put him. Wherever you want him to be. And maybe this little cloud has a little friend that lives right here with him, and they float around and have a good time."

Bob rarely painted just one single Titanium White cloud in the sky. He never painted one that was pinned down to anything. He knew that clouds had more fun when they had someone to float around with.

There's so much to do every day, isn't there? Work, school, bills—always something on the "to do" list. But it's important to take some time to enjoy yourself with someone you like. Go to a park with your friends, take your dog for a walk, go see a silly movie with your partner. Do whatever it is that keeps you connected to your loved ones, and connected to the joys of the things you want to do. That way you'll be better prepared to deal with the things you have to do.

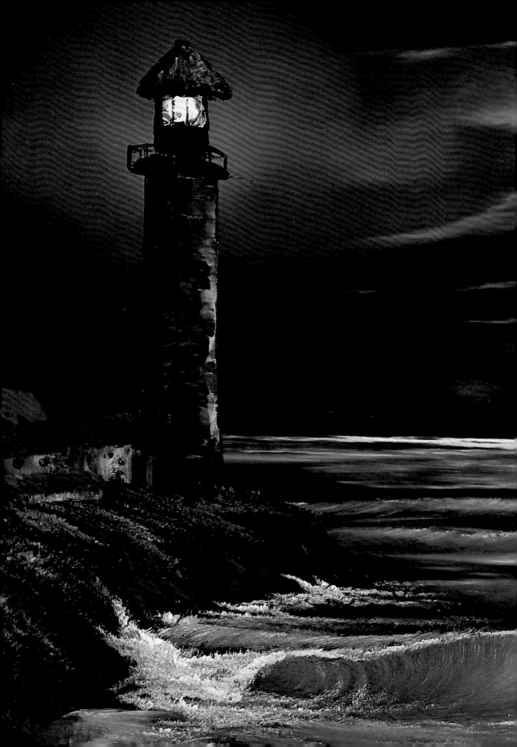

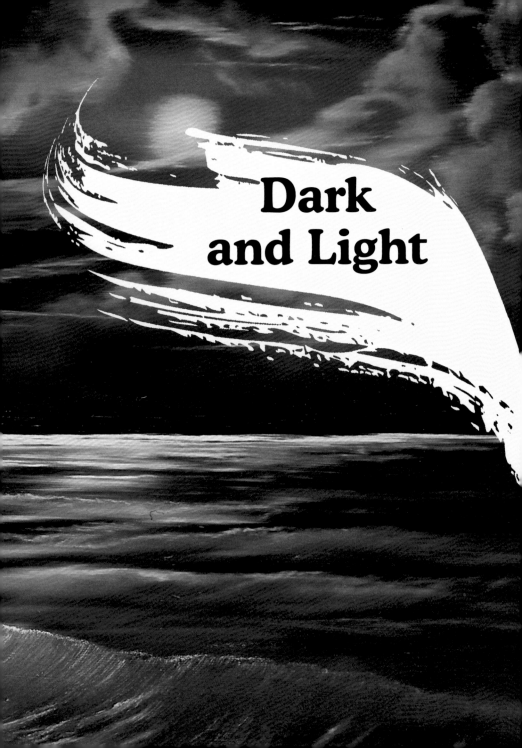

Dark and Light

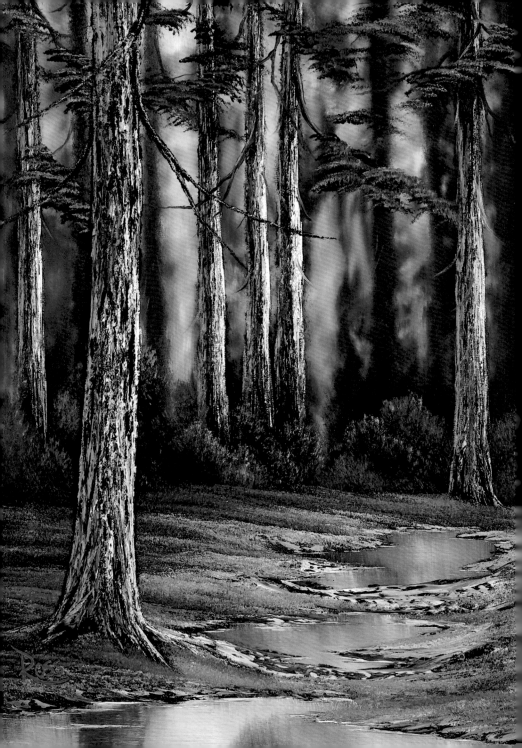

"There's going to be a nice dark shadow right in there, and we'll just let it go, have fun. Begin playing back and forth between shadow and highlight, and just visualize in your mind and let them flow right off your knife."

Whether daytime or nighttime, there are shadows cast in each scene Bob ever painted. Trees, rocks, mountains, and underbrush block the light of the sun or moon from completely covering the ground. It's what they do. The trick, as Bob proved time and again, is how to look at the shadows. In Bob's paintings, shadows are never fully black, but have some blue or even red mixed in—Bob's shadows serve to accentuate the beauty that surrounds them.

While his shadows may block your view of a happy little squirrel, just the way Bob formed shadows along the ground reveals hidden details if you learn to observe them—the lay of the land, the flow of a river, where and how high the sun is in the sky. In Bob's paintings, shadows are as valuable a part of the scene as anything else.

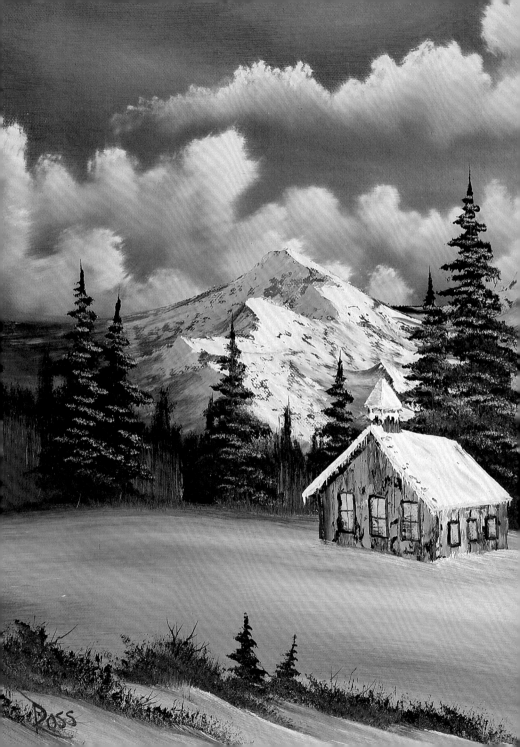

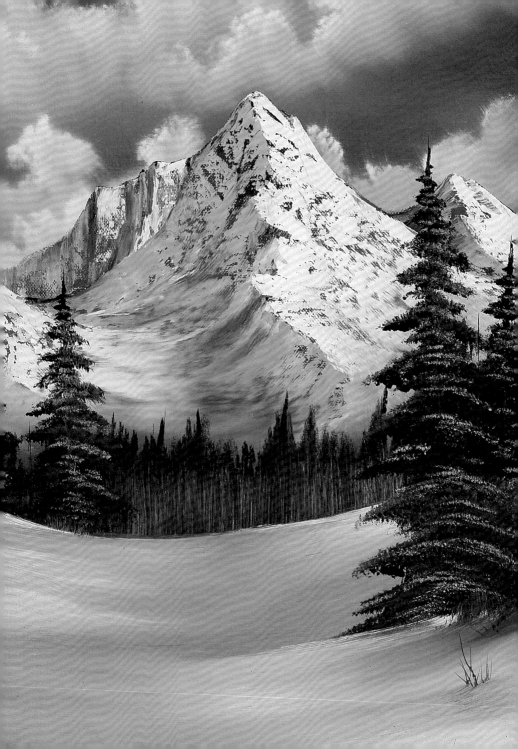

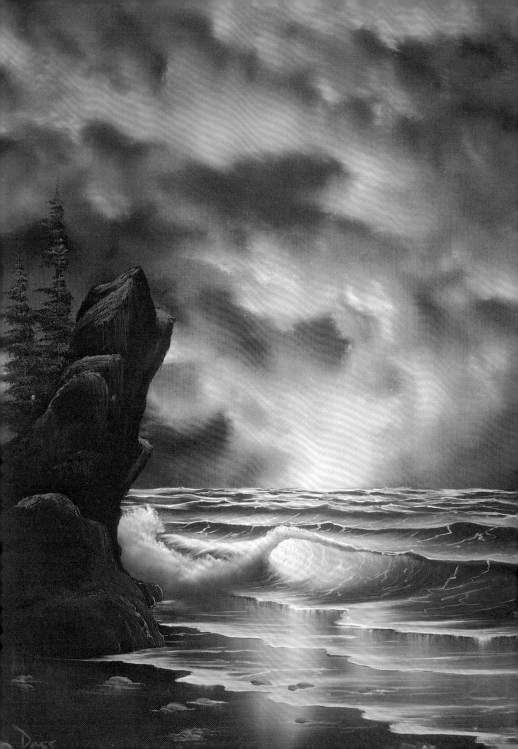

"You have to have dark in order to show light, just like in life."

Bob's paintings were always filled with a fine balance of light and dark.
His calibrations of highlights and lowlights reveal his deep appreciation for how nature plays with them to form one, cohesive scene.

Learning to acknowledge our own light and shadows is the first step to creating our own cohesive view of ourselves. Just as our ancestors harnessed fire to keep beasts away, modern methods have given us the tools to fight illnesses and unfortunate, unavoidable situations that cast dark shadows upon our lives. While society has come a long way from sitting around a campfire in animal skins, we often continue to avoid talking about or acknowledging unpleasant things. The stigma associated with mental illness is still all too prevalent, and many dinner tables are rendered silent when families decide that some things aren't "dinner conversation." In order to shine light on darkness, we must first acknowledge that the darkness is there. Sometimes our emotional shadows pass as quickly as the sun moves across the sky; sometimes our dark moments last a bit longer, affecting our personalities, our careers, and our relationships more than we care to let on. But it's these shadows that inform who we were, who we are, and who we could be. And it's only by setting them against the light that we can see the whole picture.

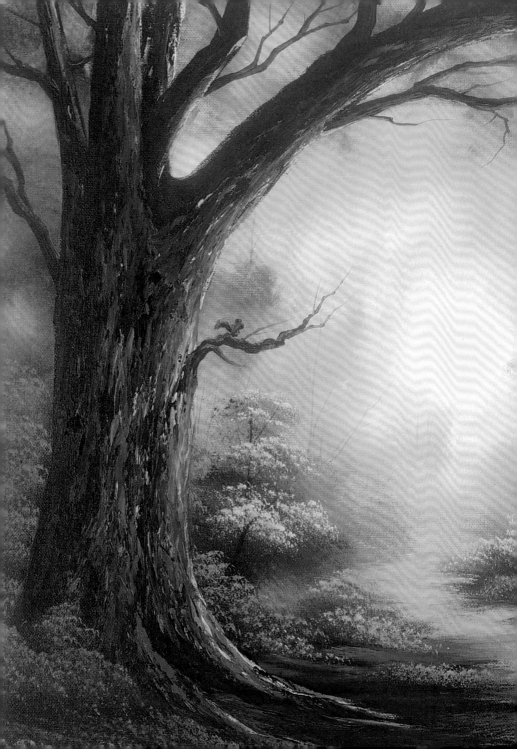

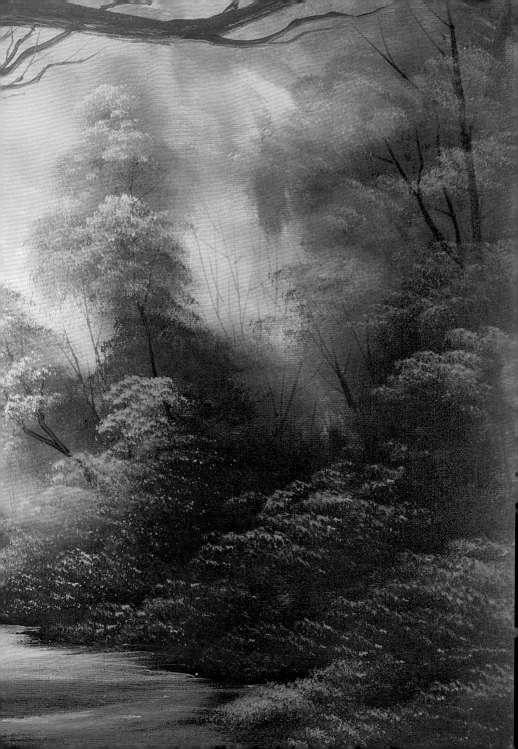

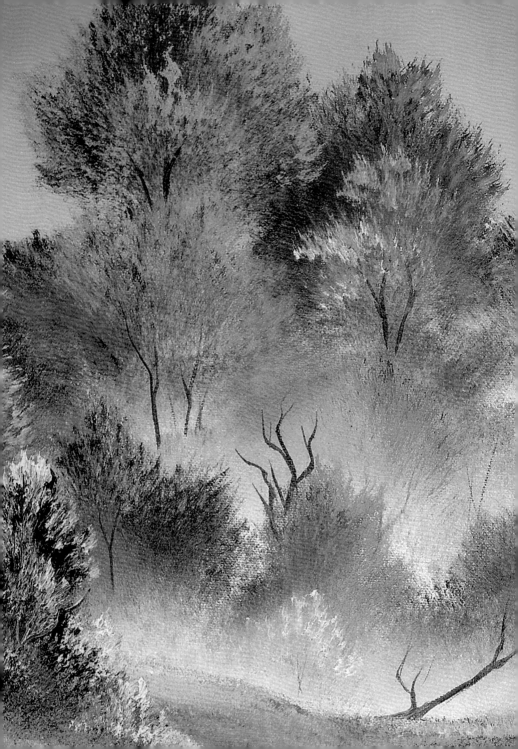

Happy Little
Accidents

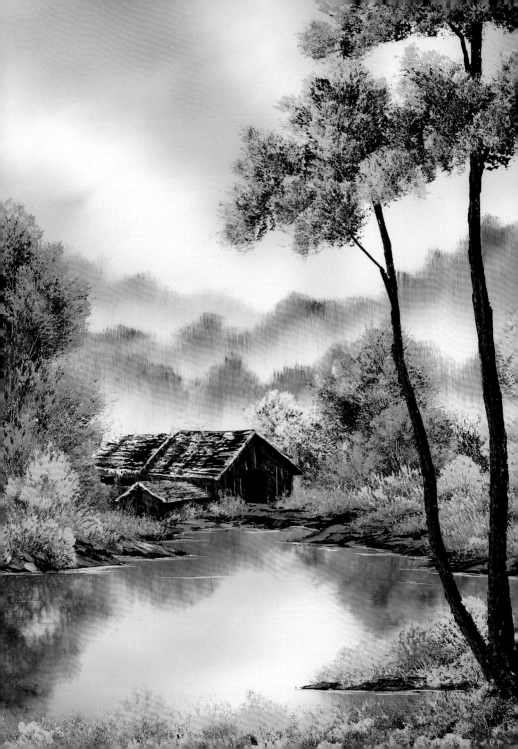

"Anything we don't like, we'll turn it into a happy little tree or something, because as you know, we don't make mistakes, we just have happy accidents."

Bob would be the first to admit that it took practice to refine his skills. His ability to create masterpieces in twenty-two minutes is unparalleled. But there were countless mistakes along the way. (Well, not mistakes—happy little accidents.) Bob recognized that while you don't usually choose things not going quite the way you'd planned, you do have a choice in how you react to such situations.

If a bit of Bright Red paint splatters on your canvas while you are cleaning your brush, you have a very important choice. You can say the painting is ruined and toss it into the garbage. Or you can decide that the splatter is a perfect place to paint a rock or tree (and cover it up). If a tree branch you'd intended to be straight turns crooked, you can camouflage it with leaves or add more angular branches and decide that's how that tree expresses itself. In his own way, Bob was showing us that when life gives you a tube of Cadmium Yellow, paint lemonade. (Just don't drink it—paint is not good for you!)

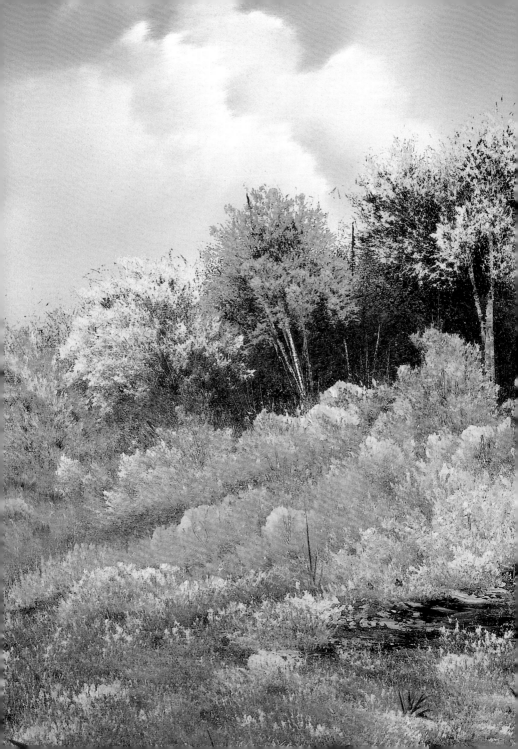

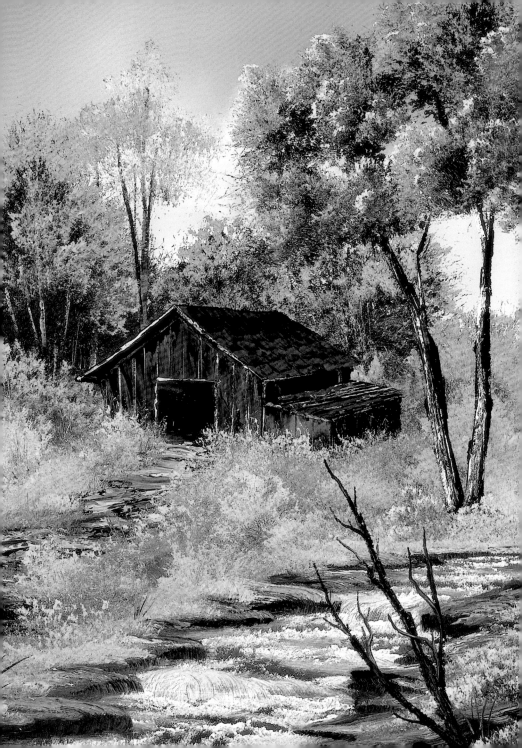

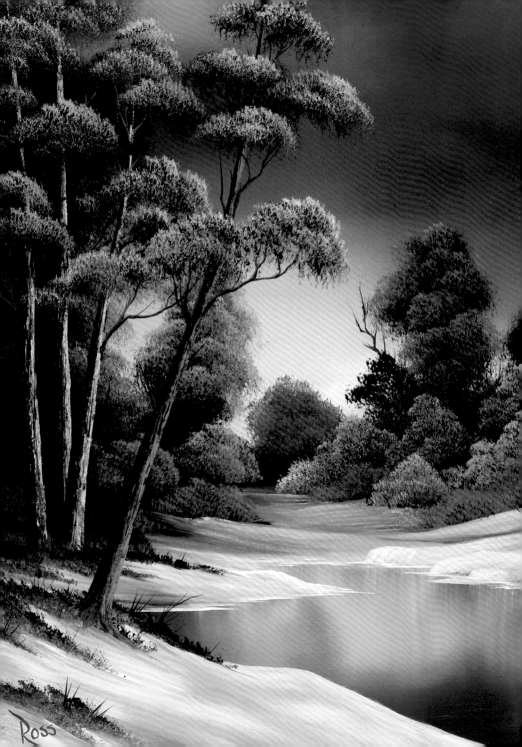

"Learn to compose as you paint.
Learn to take advantage of what happens.
Happy accidents can be your best friend."

You've made mistakes, haven't you? If you haven't, then you're perfect—a perfect liar, that is. We all make mistakes; it's what people do. And though we can't change what happened, we can control the aftermath. Every mistake is a chance to learn something about yourself: Did you take a shortcut? Were you not paying attention? Every mistake is a chance to correct course so you can try to avoid finding yourself in the same situation again. (Maybe you'll look behind you before swinging your backpack on next time.)

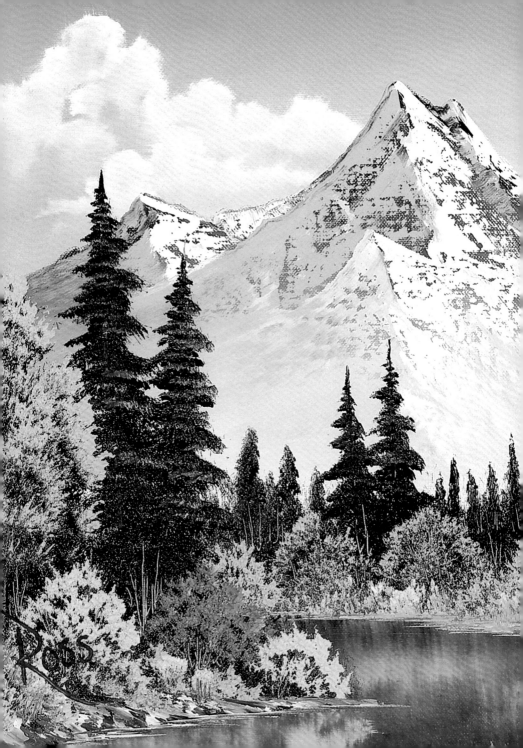

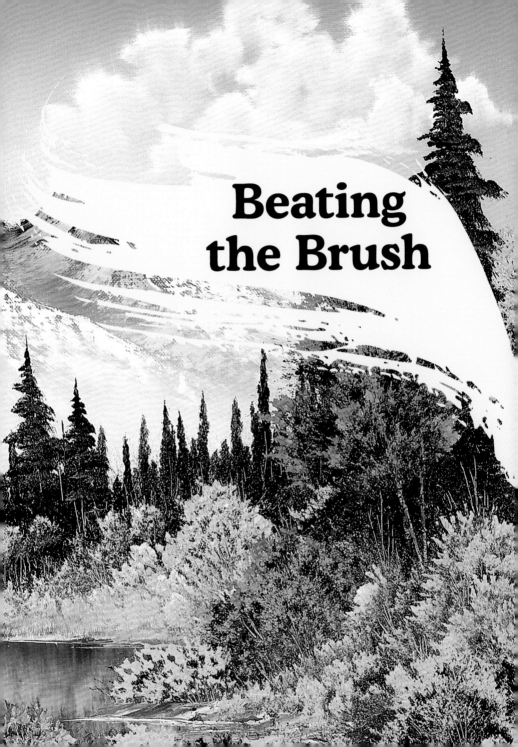

Beating
the Brush

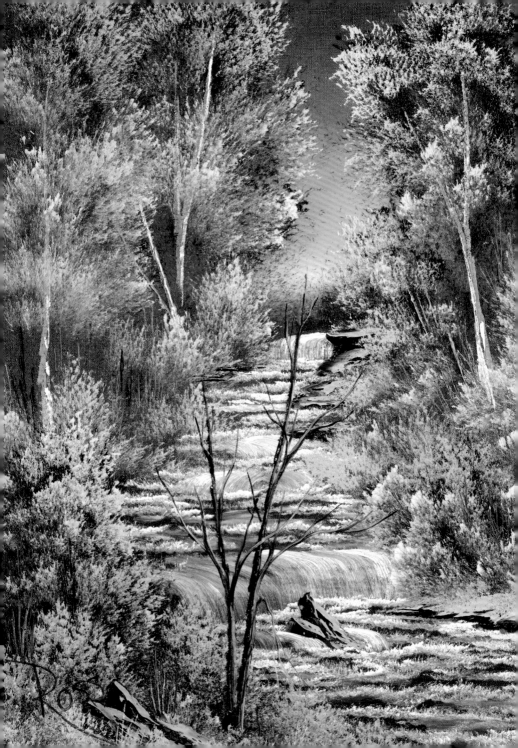

"Let's wash the old brush—here's the fun part. Shake off the excess and just beat the devil out of it."

Bob kept his brushes clean. His television shows were twenty-two minutes of meditative ASMR. His soothing voice rarely went above library-level volume, and his movements were always smooth, yoga-like exercises in control. Except for when he was cleaning his brushes. After dipping a paint-filled brush in a container of paint thinner, Bob seemed to take great pleasure in beating the excess liquid out of it by slapping the brush against an easel leg. On a practical level, Bob understood that a clean brush is essential to combining the colors properly for the effect you desire. But on an emotional level, you could tell that Bob was getting a kick out of letting off some steam!

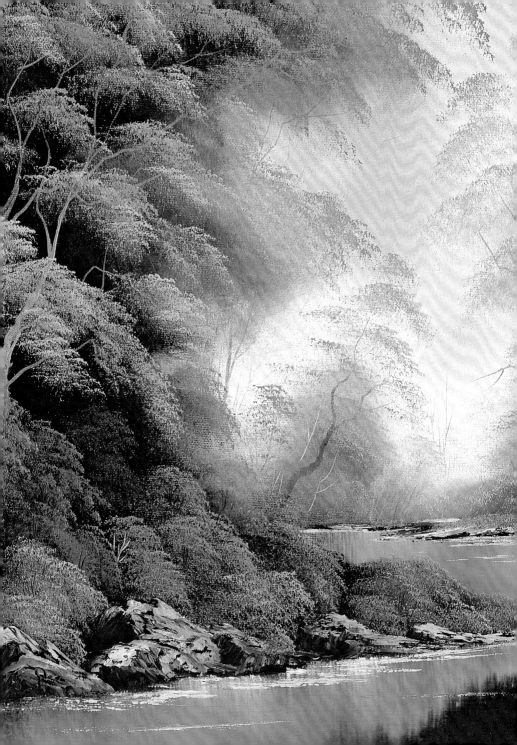

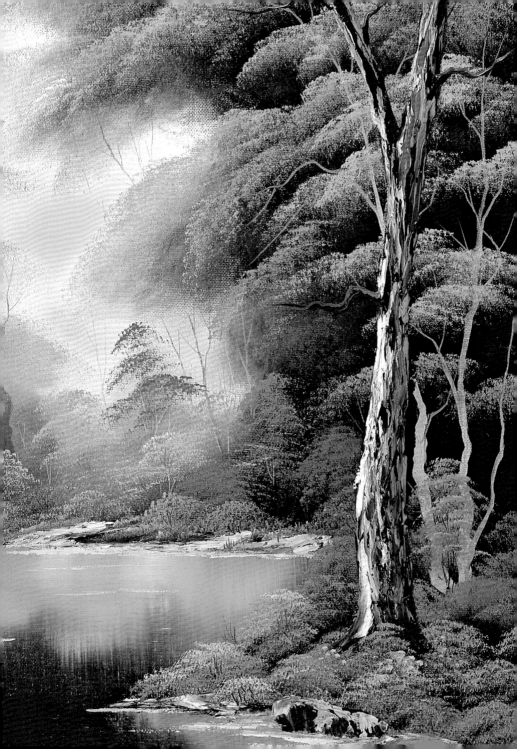

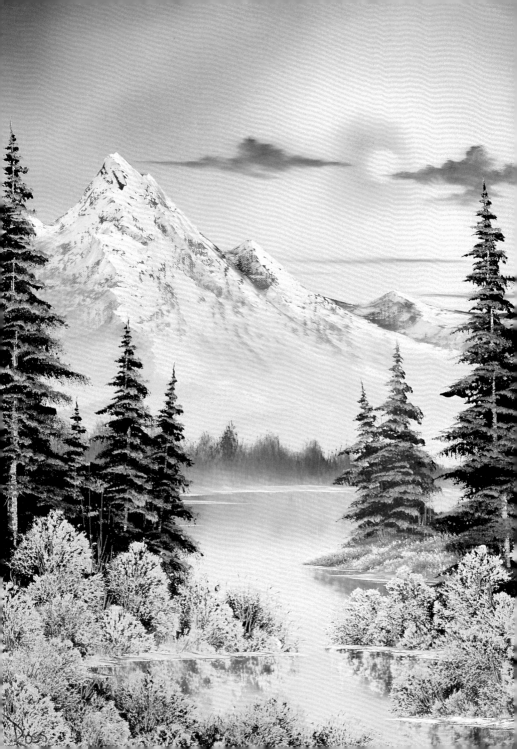

"These things live right in your brush—all you have to do is shake them out."

It's important to tackle your problems with clarity and intention. Imagine your body is a brush that picks up the different colors of emotions you feel throughout the day: some Bright Red anger, a little Sap Green of jealousy, a dollop of Midnight Black frustration. By the end of the day, all of your feelings are mixed together, leaving your bristles matted with a complicated blob of blended—and confusing—emotions. It's vital to remember to release yourself from the sticky feelings you're holding on to.

Sometimes, as Bob demonstrated, physical exercise is a great way to let go of unwanted stress. Try attending a karate class, or dance around your bedroom to your favorite high-energy playlist. Go for a run or a walk around the block. By getting your body moving, you're giving yourself the opportunity to divert your attention from those feelings (or remove yourself from a challenging situation) and gain the mental clarity to work through whatever's bothering you.

Just as Bob emphasized beginning with a clean brush so you know exactly what colors you're working with, it's important to get rid of as much unwanted emotional baggage as you can so you can start (or restart) with a fresh outlook.

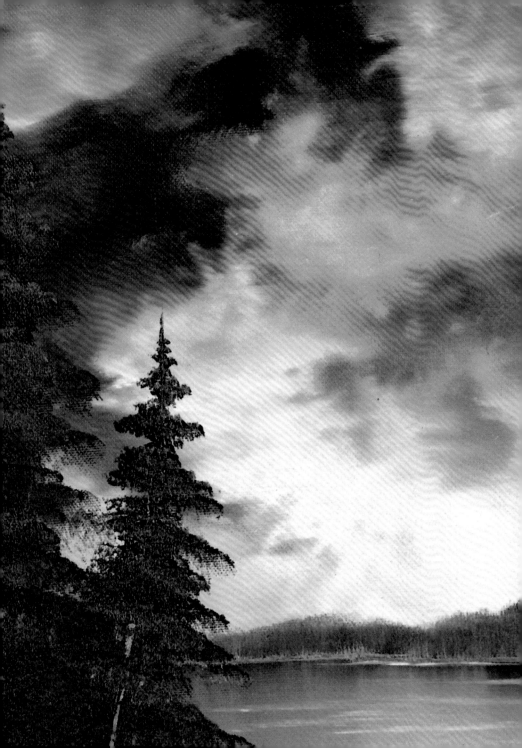

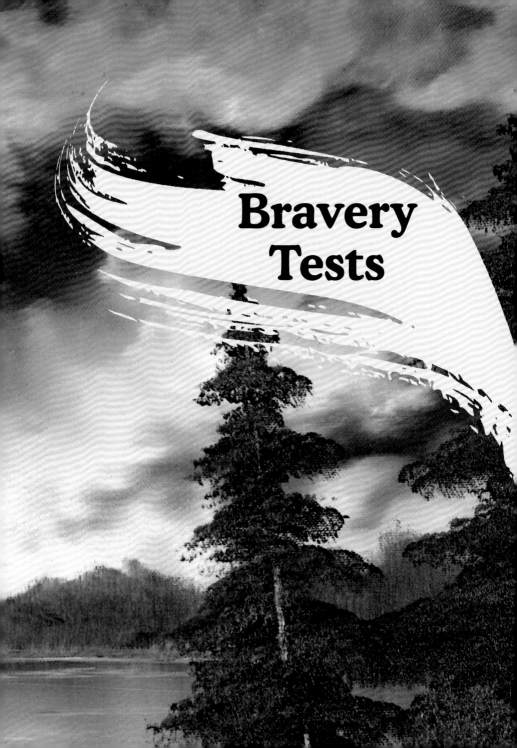

Bravery Tests

"Let's get crazy, what the heck. Take a two-inch brush— this is your bravery test!"

As an artist, Bob understood when it was time to take a risk. Through thousands of classes, he gave his students the fundamentals of painting using the wet-on-wet method. And, every once in a while, he introduced a "bravery test." He might be nearly done with a perfectly nice painting, when all of a sudden he would plant a big tree trunk right in the center of it. Truly a no-turning-back moment!

Sometimes you need to shake things up. When you feel everything is going along like clockwork, that's the time to give yourself a bravery test. Yes, it can be a little scary—you could fail, whether you're changing a painted tree to a snow-covered mountain or making a big-life-changing decision. But, as Bob said when he seized his two-inch brush, "What the heck!" He trusted that what he learned from trying something new was always worth the risk of failure.

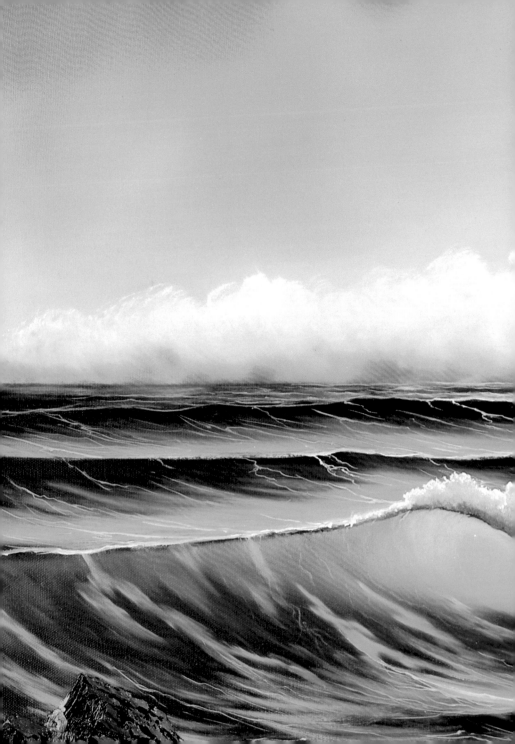

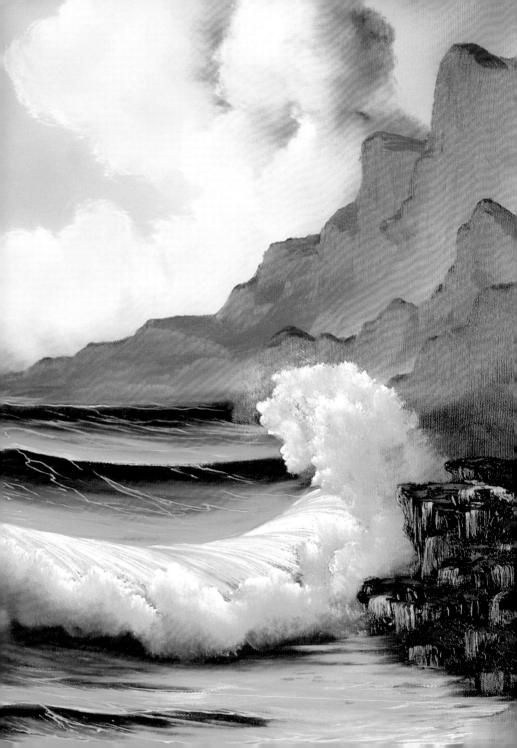

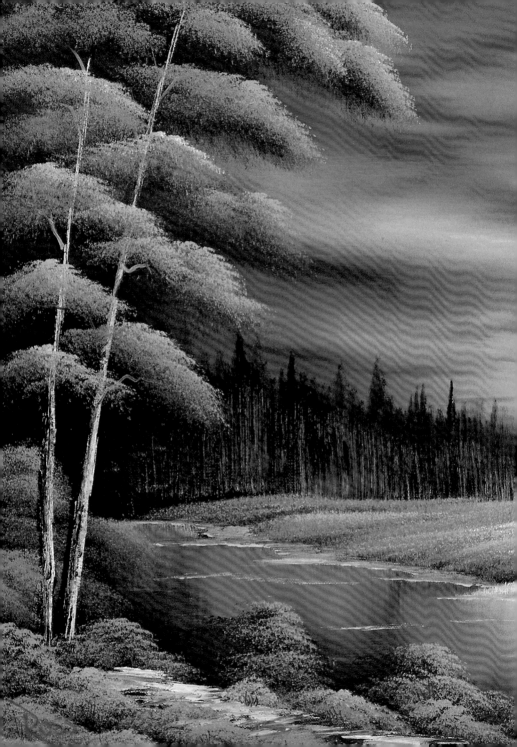

"There. I knew you could do it."

Bob seized the opportunity to be brave—and you can too. After a slow start, with the help of friends and family, Bob's classes became so well attended that he (probably) could have had a successful career teaching art classes in his home state of Florida and around the country. But Bob was never one to rest on his Phthalo Green laurels for too long. Instead, he and his friends went into business together to create a company that was designed with the specific goal of bringing art and art instruction to as many people as possible. Starting any business is at best a risk—and at worst a colossal financial disaster—but he seized the opportunity to be brave and, as a result, cofounded one of the most successful art-based businesses in history. This is to say nothing about Bob's agreeing to put himself on television!

How many of us would have the confidence to commit to a series in which you and your artistic works are on full display—and have it supported not by commercials but by the very public you're putting yourself in front of every week?

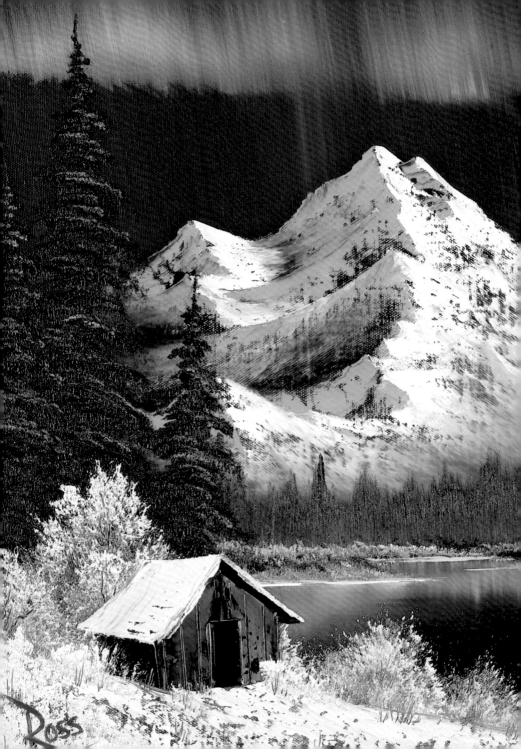

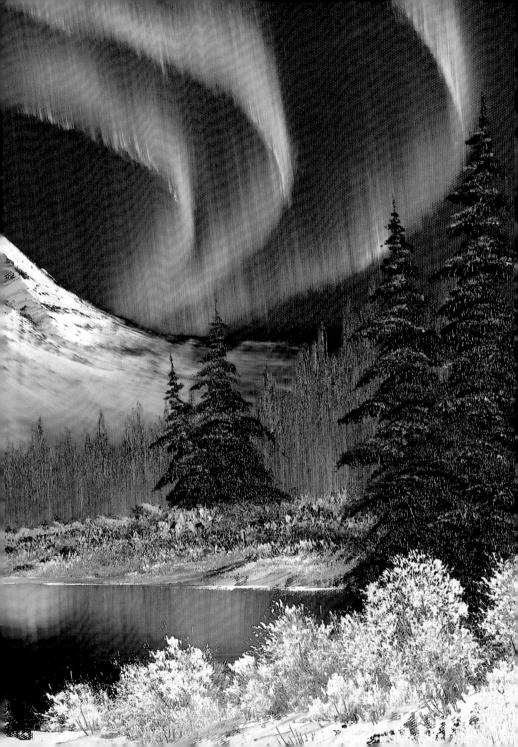

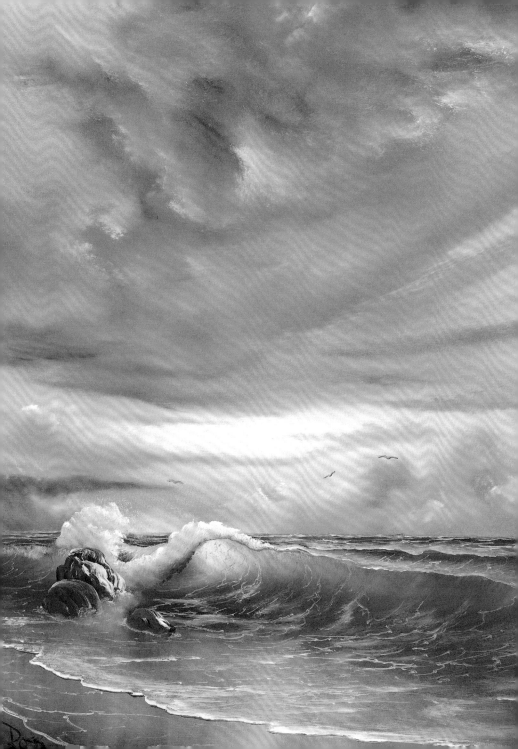

"You'll never believe what you can do till you get in there and try it."

By focusing on the opportunities, rather than fears, of bravery tests, you're opening yourself up to the you that you didn't think you could ever be. Many of us are creatures of habit. We like routines and knowing, for the most part, what to expect in our day-to-day lives. But we can recognize that the "same old same old" can get, well, old. We need variety to keep us moving forward, to prove to ourselves that we can evolve and learn. For some of us it's taking a painting class or learning how to box; for others it may be skydiving or running a marathon. Some people find meeting new people difficult, while others are reluctant to wear what they love for fear of ridicule. Regardless of the activity, the point of a bravery test is to push yourself to try something new, test your boundaries, and open yourself up to the idea of change. You really never know what will come of it. Maybe you'll never do it again, maybe you'll find a new hobby you enjoy, or maybe you'll wind up getting to work with a class full of students who were just like you a few months ago.

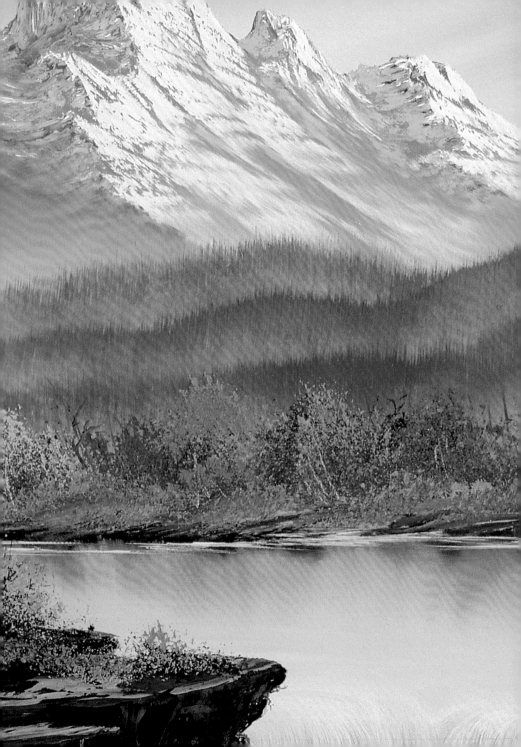

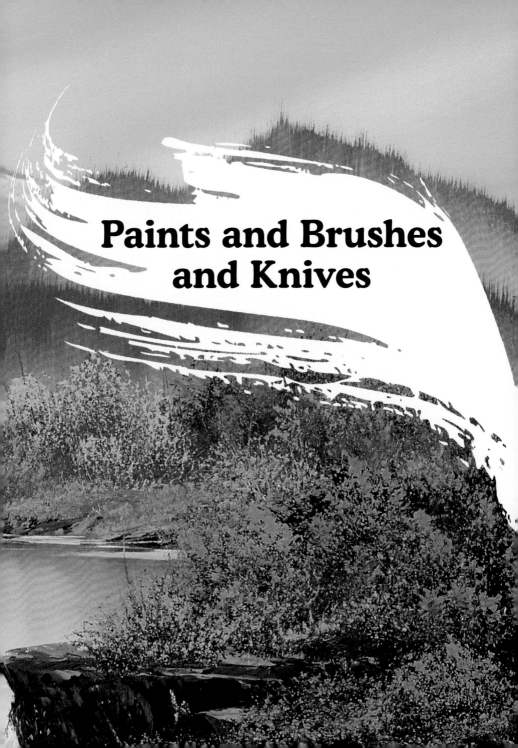

Paints and Brushes and Knives

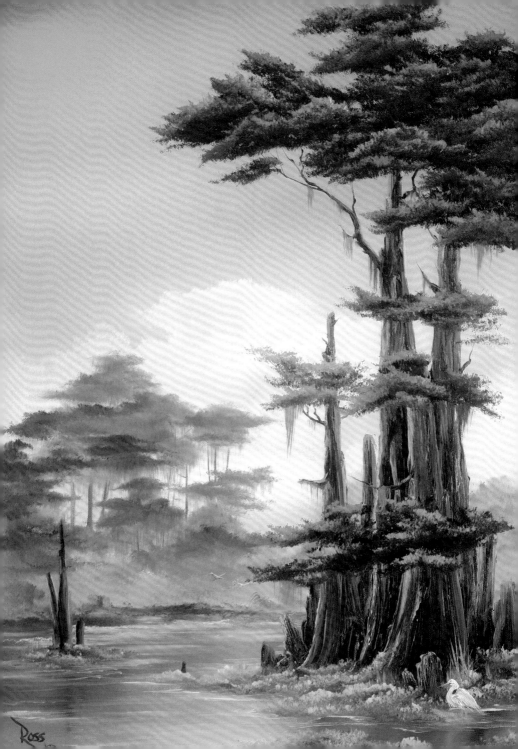

"A fan brush is one of the most unique and individualized brushes there are, and it'll do unbelievable things for you, once you make friends with it."

You need to use the right tool for the job. Perhaps Bob learned this lesson from his experiences as a carpenter and in the military. Fan brushes are great for adding foliage but don't work for painting your signature. A palette makes a great paint holder, but it is a lousy place to clean a brush.

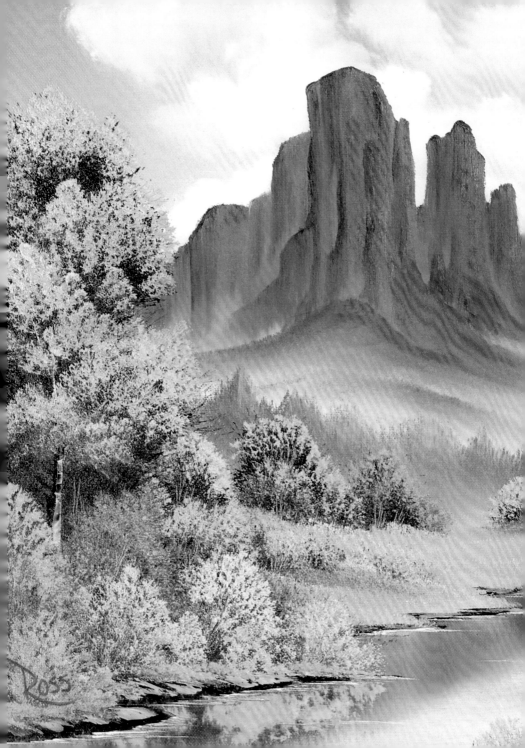

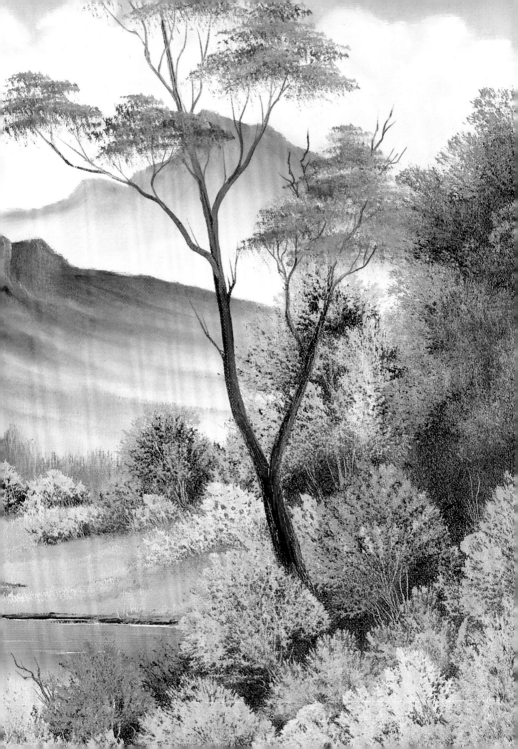

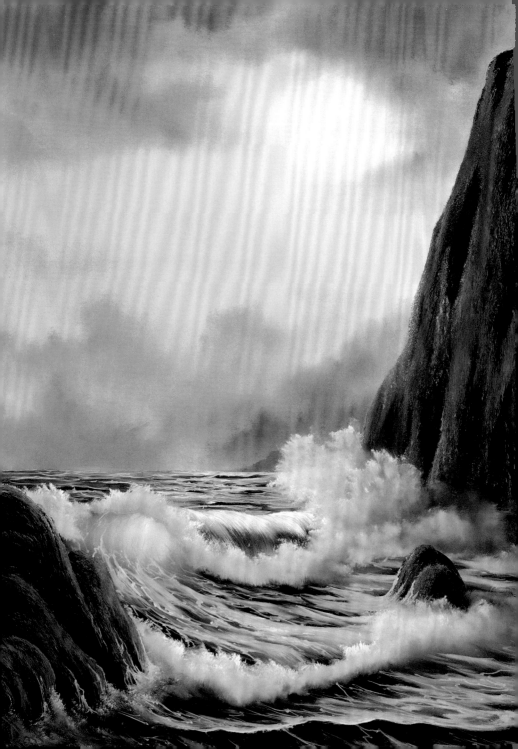

"Find out what works the best for you, and that's what you want to use."

You have the unique ability to identify—and utilize—the tools and gifts that you have (and the ones you don't). Many people are amazing mathematicians, while some of us still use our fingers to add and subtract. Does that make the latter group less valuable than the former? Hardly! It just means that they probably shouldn't do their taxes by themselves. Recognizing the things you do well allows you to advance in those areas, and share your gifts and talents with others. (If you're great at cooking, then invite everyone over for dinner!) There should be no shame in acknowledging the things you need help doing, and the things you're going to do anyway, no matter your skillset. (So who cares if you can't carry a tune—karaoke night can still be fun!)

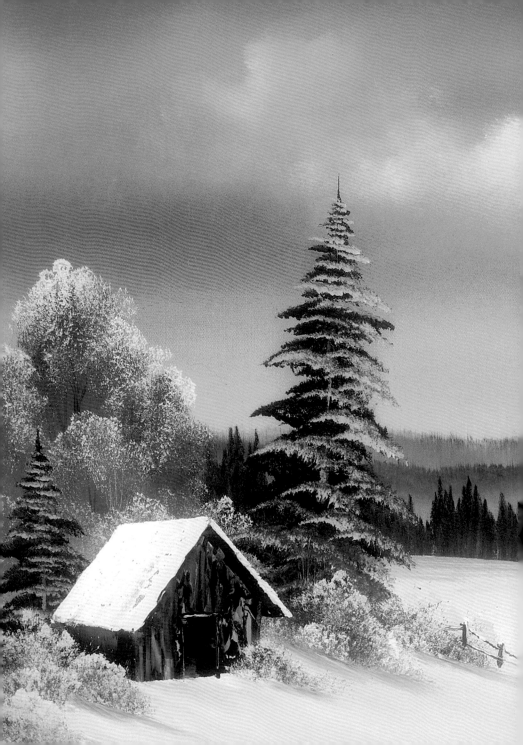

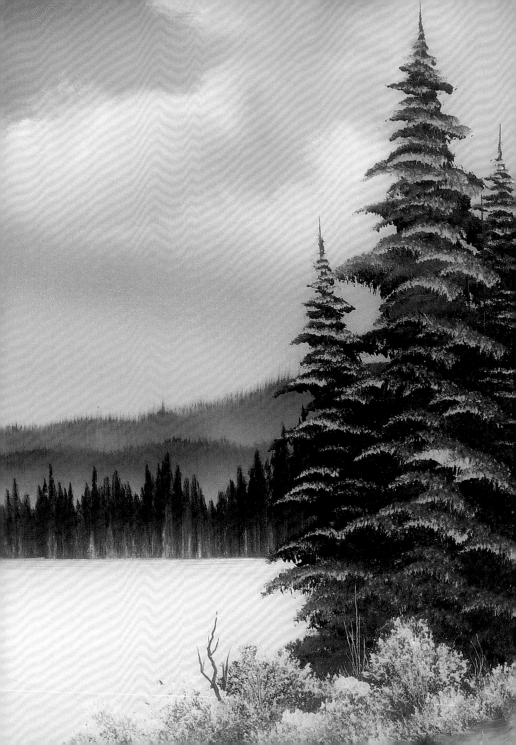

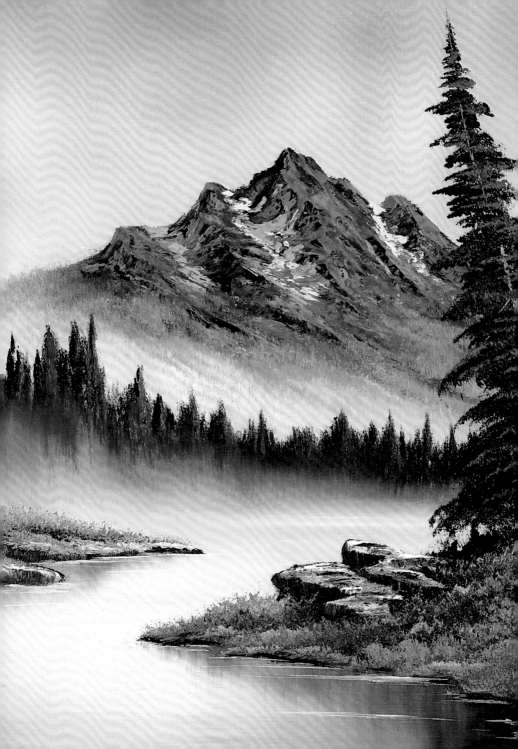

*"I look forward to seeing
you again. Happy painting, and
God bless, my friend..."*

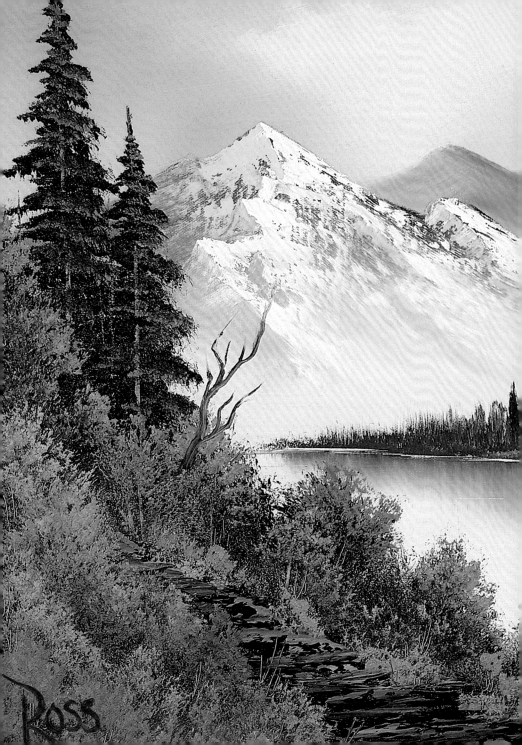

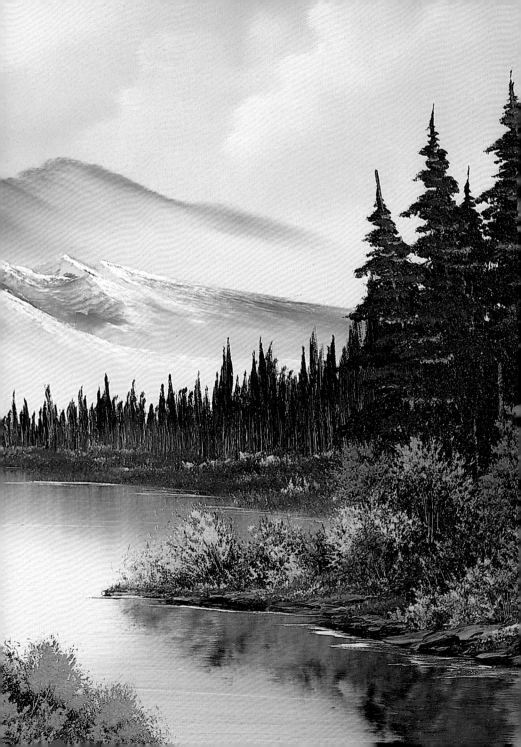

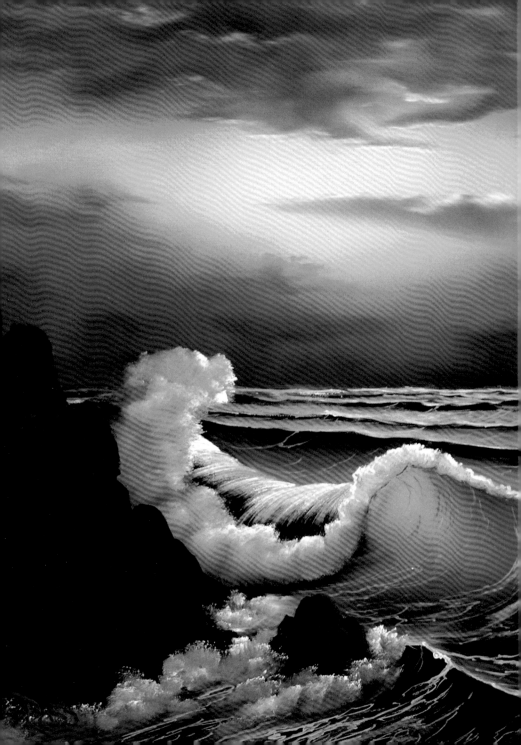

Thanks and Acknowledgments

Thanks must, of course, first be given to Bob Ross for inspiring generations to create, think, and float like a happy little cloud. I'm very grateful to the great and good Joan Kowalski for her trust and for the honor of being even a small part of Bob's legacy; and Cynthia Modders, Pamela Harris, and Marsha Armitage-Bristow for the opportunity to play with all of the colors on Bob's palette. Sincere thanks must also be layered onto the designer, Lynne Yeamans, and my editor and friend, Elizabeth Smith.

First published in the United States of America in 2020 by
Universe Publishing,
A Division of
Rizzoli International Publications, Inc.
300 Park Avenue South
New York, NY 10010
www.rizzoliusa.com

Publisher: Charles Miers
Editor: Elizabeth Smith
Design: Lynne Yeamans / Lync
Production Manager: Colin Hough Trapp
Managing Editor: Lynn Scrabis

Printed in China

2022 2023 2024 / 10 9 8 7 6 5 4

ISBN: 978-0-7893-3801-3
Library of Congress Control Number: 2019947962

Visit us online:
Facebook.com/RizzoliNewYork
Twitter: @Rizzoli_Books
Instagram.com/RizzoliBooks
Pinterest.com/RizzoliBooks
Youtube.com/user/RizzoliNY
Issuu.com/Rizzoli

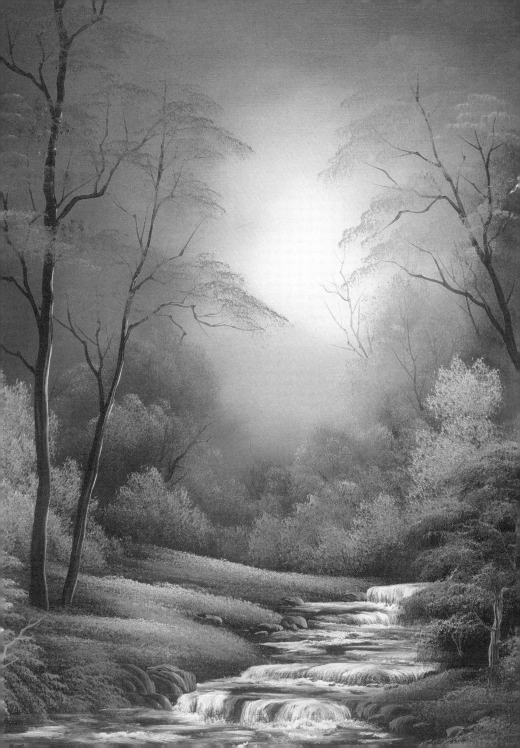

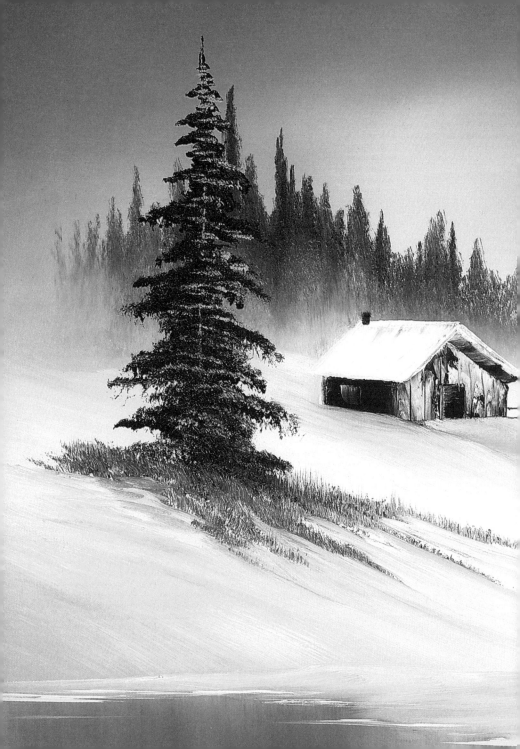